LLANELLI
THROUGH TIME
Keith E. Morgan

AMBERLEY PUBLISHING

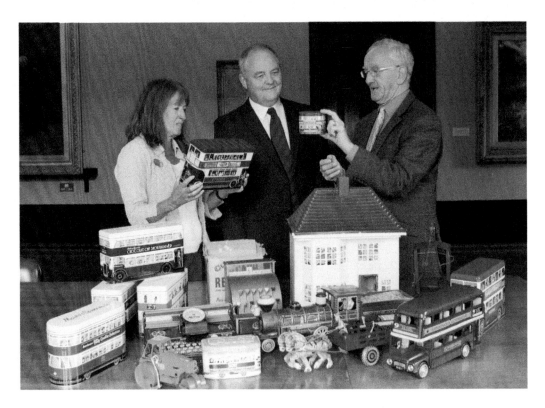

Parc Howard Museum, Llanelli
The author donating his collection of tinplate toys to Llanelli's Museum at Parc Howard in August 2014. The collection, of only which a small part is shown, was received on behalf of Carmarthenshire County Council Museum Services by Gavin Evans, curator, and Ann Dorset, retired curator. Amounting to well over 250 pieces, and still growing, the collection will be on permanent display at Parc Howard and at other museums within the county.

This book is dedicated to Malvina, 'My Special Angell'

First published 2014

Amberley Publishing
The Hill, Stroud, Gloucestershire, GL5 4EP
www.amberley-books.com

Copyright © Keith E. Morgan, 2014

The right of Keith E. Morgan to be identified as the Author of this work has been asserted in accordance with the Copyrights, Designs and Patents Act 1988.

ISBN 978 1 4456 4282 6 (print)
ISBN 978 1 4456 4295 6 (ebook)

British Library Cataloguing in Publication Data.
A catalogue record for this book is available from the British Library.

Typesetting by Amberley Publishing.
Printed in the UK.

Introduction

In preparing this book on Llanelli, I have been fortunate to be able to call upon what is considered to be the definitive history of Llanelli, that book entitled *Old Llanelly*, as published in 1902 by renowned local historian John Innes. This book, and the notes and photographs that went with John's book, have provided a wealth of information on Llanelli covering up to the beginning of the twentieth century. Of equal importance as a source of modern history of Llanelli is a book by another John, entitled *Llanelli: Story of a Town*, and published by fellow local historian and author John Edwards. This book of John's is best described as a treasure trove; an Aladdin's cave bristling with information and dates.

I have tried to cover the history of Llanelli in pictorial form from when it was a small medieval fishing hamlet on the sea shore of the Burry Estuary, through its period known as 'Tinopolis' and the centre of the world's tinplate industry, to its present-day importance as a thriving urban, commercial and industrial town. Llanelli is the largest town in the county of Carmarthenshire, and I have logically tried to follow a route from the River Loughor in the east, which the traveller first crosses to enter this county, through Llanelli itself and on to Burry Port and Pembrey in the west. I must admit that in this volume I have largely skirted around the industrial history of the town and only touched on it here and there. As John Edwards so eloquently puts it in his book and which I have taken the liberty to quote here:

> The old works, which created our town, have all been swept away. The first works were planted here on green fields 200 years ago and many more were added in the following 100 years. Now, they have all disappeared and we are back to green fields again.

Yes, as a consequence, it was coal mining, copper smelting, shipping and tinplate that made Llanelli and the importance of the town's industrial heritage will be covered in a subsequent publication. This book, however, concentrates on the domestic, urban, commercial, religious, and sporting history of Llanelli. After all, Llanelli has claim to fame as the home of the Scarlets rugby football club; the team that made its name and that of the town by beating the All Blacks rugby touring side 9-3 in October 1972.

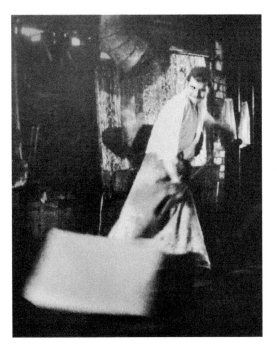 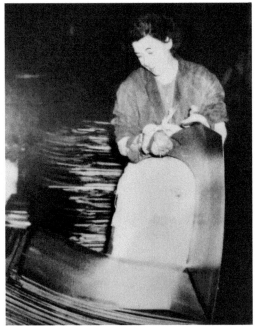

Industrial Symphony

Bronze Monument by sculptor Peter Walker in Upper Park Street dedicated to the many generations of men and women who worked in the tinplate industry, forging the proud history of Llanelli. Erected in September 2014 by Henry Davidson Developments and Carmarthenshire County Council, a furnaceman is caught in slow motion as he skids a sheet of hot steel across the mill shop floor while the opener is splitting sheets apart from a pack. The photographs below are two of the many from the archives of the Trostre Works Cottage Industrial Museum that inspired Peter Walker in his final design for the sculpture.

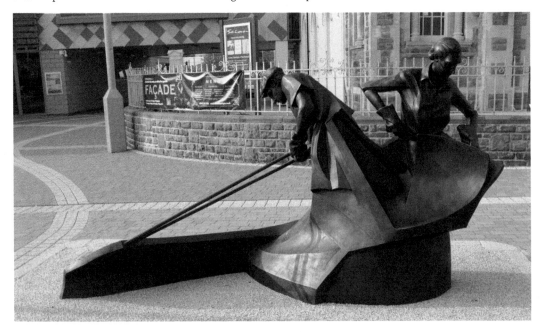

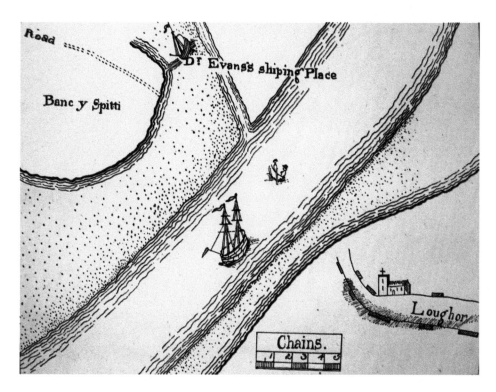

Road

Dr Evans's shiping Place

Banc y Spitti

Loughor

Chains.

The Gateway to Llanelli

Ever since Roman times, and possibly even before, the crossing of the River Loughor at Spitty has provided an important gateway to Llanelli and the countryside beyond. The top illustration is of the *Spitty* Ferry in 1772 while the lower photograph shows the two state-of-the-art bridges that currently link Llanelli to today's modern roads and high-speed rail network.

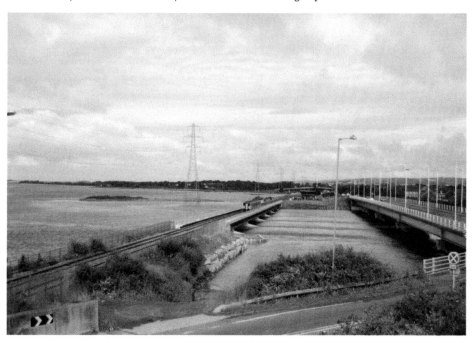

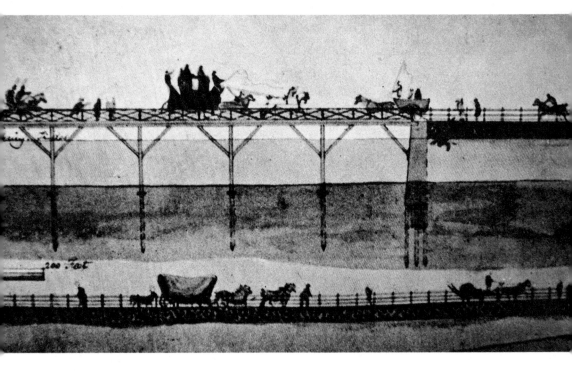

Crossing the Loughor River

Another early sketch that shows the volume of traffic crossing the first wood trestle road bridge in 1832. The lower photograph captures this 700-ft long trestle bridge in 1920, before it was demolished in 1922 to be replaced by a more substantial concrete and stone bridge the following year.

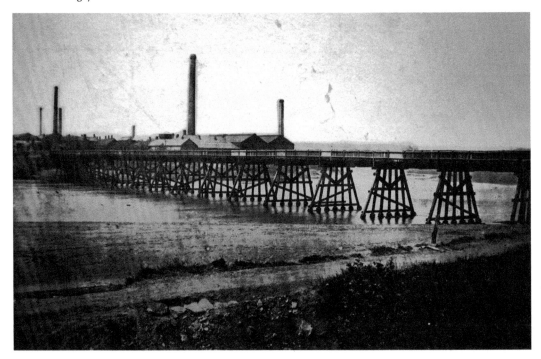

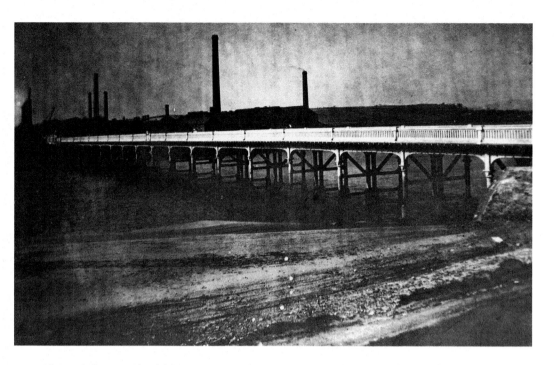

The Loughor Road Bridges

The top photograph shows the second road bridge as built across the River Loughor, opened on 24 April 1923. This served its purpose well until 1988 when the current steel bridge, shown in the lower photograph, was constructed just a short distance downstream. All that remains to be seen of the previous two road crossings are the wood trestle bridge stumps in the riverbed at low tide, and the stone bridge buttress on the Loughor side of the river.

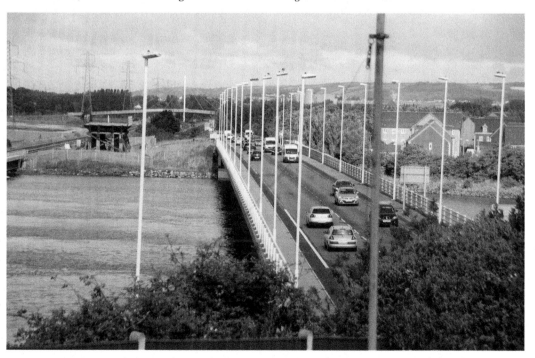

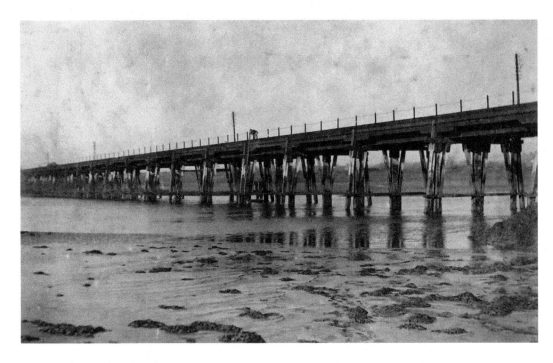

The Loughor Railway Bridges

On 1 September 1851, work began on the foundations of the first railway bridge to cross the River Loughor. This new timber dual-broad gauge track viaduct had been designed by Isambard Kingdom Brunel, but was actually constructed by a Mr Brodie who was the engineer of the South Wales Railway. Until recently replaced, it was the sole surviving example of Brunel's once numerous timber viaducts. Replacement work started in 2011, when exploratory drillings were carried out, as shown in the lower photograph.

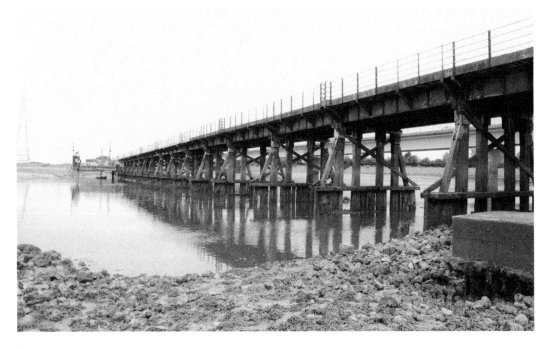

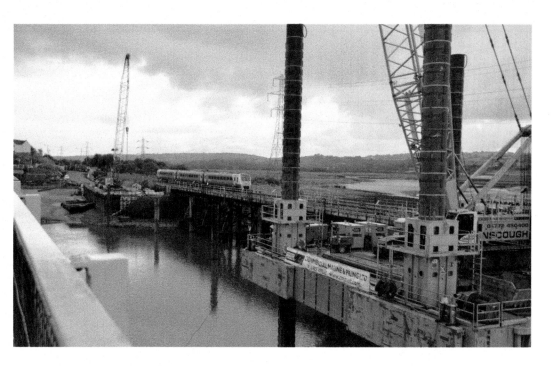

Loughor Viaduct Replacement
In order not to disrupt the existing train service, the new bridge was constructed on temporary piles alongside the existing viaduct before being slipped across to take the place of this structure when it was removed. This is illustrated in the two photographs, which show the pile driving in progress. Afterwards, the new dual-track bridge was slid into its final position before the temporary pile structures were removed.

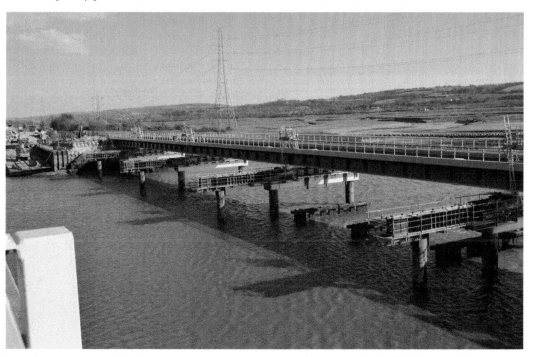

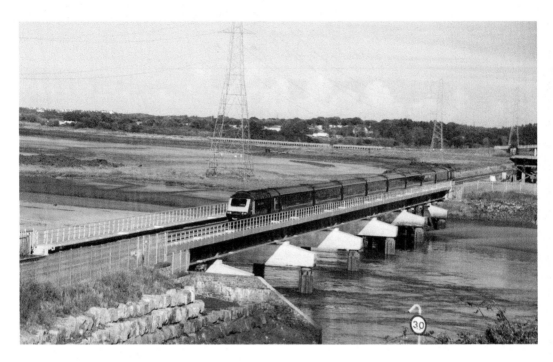

The New Loughor Railway Bridge

The new dual-track railway bridge was opened to regular rail traffic in April 2013. The top photograph, taken on 15 August 2014, shows the early morning 07.05 a.m. HS 125 Express from Milford Haven travelling across the new bridge at high speed, which it was not allowed to do on the old bridge. As a contrast, the lower photograph of the same day captures a local push-pull passing the preserved remains of a section of Brunel's wood trestle viaduct, erected alongside the new track.

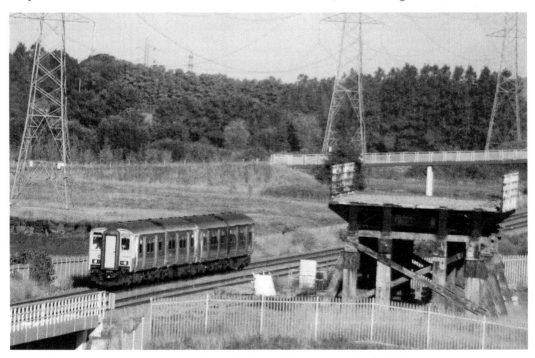

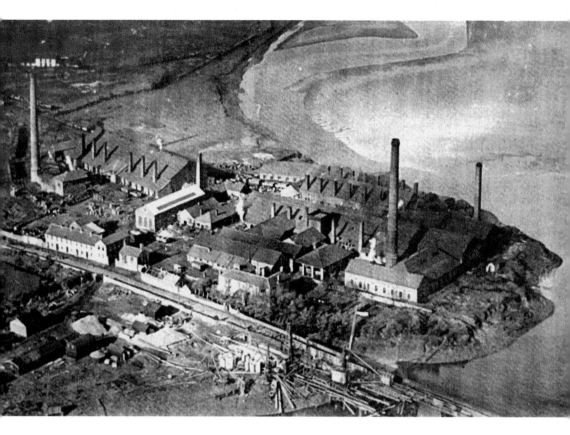

Evidence of Industry

Originally the site of the Spitty Bank Copper Works (closed in 1857), it was converted in 1869 to the St David's (Yspitty) Tinplate Works, Bynea. The latter works is shown on the right of the top photograph taken in 1923, while part of the Bynea steelworks is on the left. Also shown in the foreground on the right, is the construction of the second road bridge over the River Loughor. The St David's Tinplate Works was the last to close in 1957, and the site is now occupied by the INA bearings factory of Schaeffler (UK) Ltd.

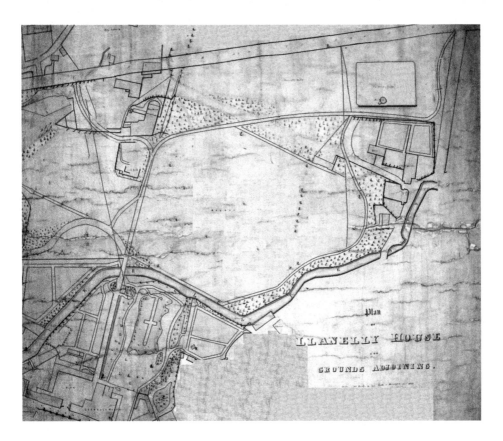

Roman Llanelli

There is strong evidence of the Roman occupation in Llanelli. The Llanelly House map of 1841 (drawn unconventionally with the south to the top), shows a rectangular earthwork/enclosure in the top right-hand corner, which has been designated the Old Roman Camp. Earlier plans show and entitle this typical Roman style enclosure as Old Castle. A number of Roman coins have been found in the area, including the AD 82 example shown of the Emperor Domitian.

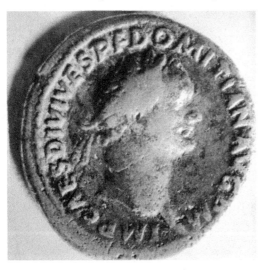
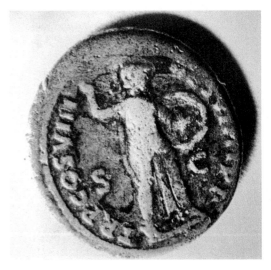

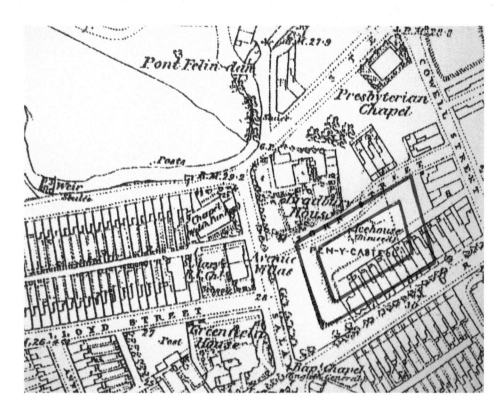

Pen-y-Castell

The outline and envisaged extent of the possible Roman camp have been coloured red and superimposed on the 1880 OS map of Llanelli, where it is designated Pen-y-Castell. The site of the camp has been honoured with a blue plaque in John Street, and as the photograph of August 2014 shows, the whole south-west corner of the earthwork is now occupied and covered by castle buildings.

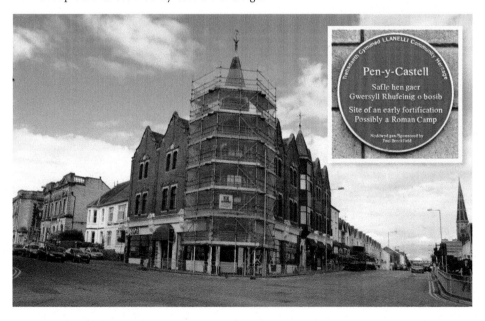

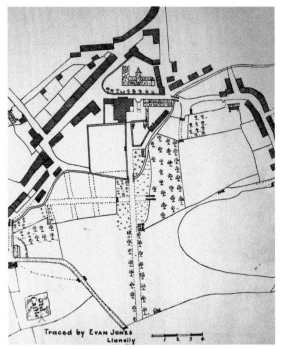

Traced by Evan Jones
Llanelly

John Innes, Local Historian and Author
In 1902, John Innes published his book *Old Llanelly,* the first, and possibly the only, complete history of the 'tinplate town' produced up to that date and since. The author has drawn extensively on John's work in the preparation of this book by using photographs, sketches and maps (such as the 1761 map of Llanelly, shown), from his collection. The original of the accompanying photograph of John Innes is appropriately printed on tinplate.

CM 1 2 3 4

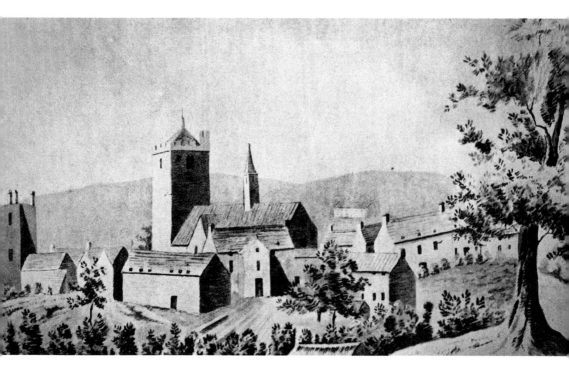

Llanelli Parish Church

The top sketch has been taken from the facing page of John Innes' book *Old Llanelly* and shows a south-east prospect of Llanelly in 1785. As a comparison, the accompanying photograph, taken from the roof car park area of the Tinopolis building in July 2014, has attempted to capture the same view today of St Elli, the parish church, and its environs.

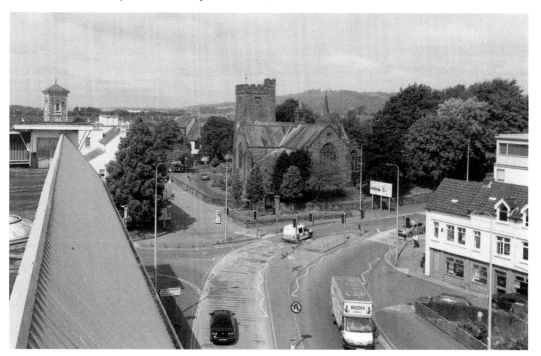

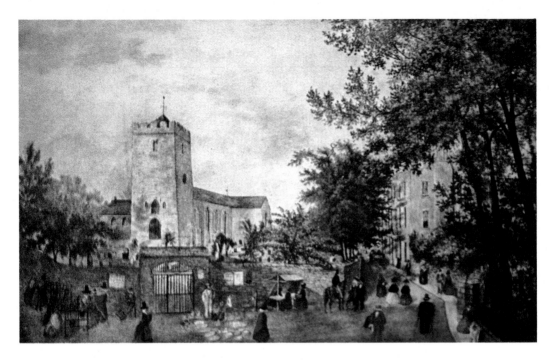

The Parish Church of St Elli

The coloured sketch by Mrs Harvard, a prolific local artist, gives us a detailed picture of community life as she saw it in 1854. The drawing highlights St Elli's church (*centre*), Llanelly House and Dr Cook's residence (*right*), the Lych Gate and extent of the churchyard, the man in the stocks, the town crier and the peddlers selling their wares of crockery, stockings and shoes; a far cry from today's photograph, where the church is obscured by trees and there is not a soul in sight.

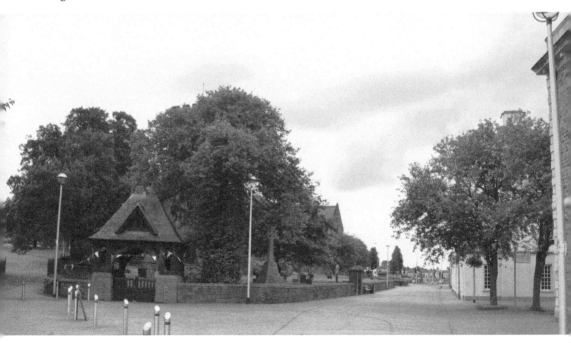

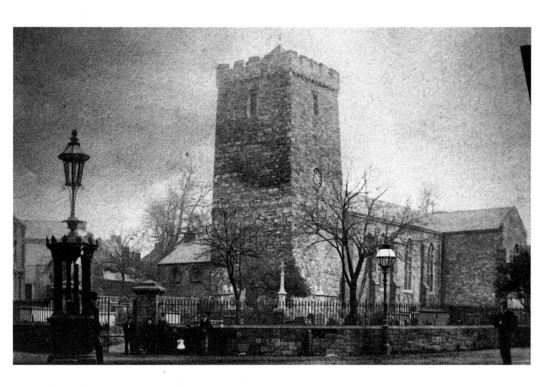

The Parish Church of St Elli

The top picture shows the parish church as it appeared in Arthur Mee's book of 1888 entitled *Llanelly Parish Church*. It contrasts with today's depiction of the church, which was rebuilt in 1905. It is clear that the tower is the oldest part of the church, and this is generally attributed to the twelfth century.

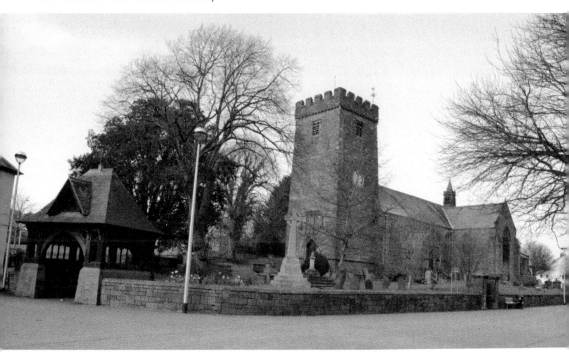

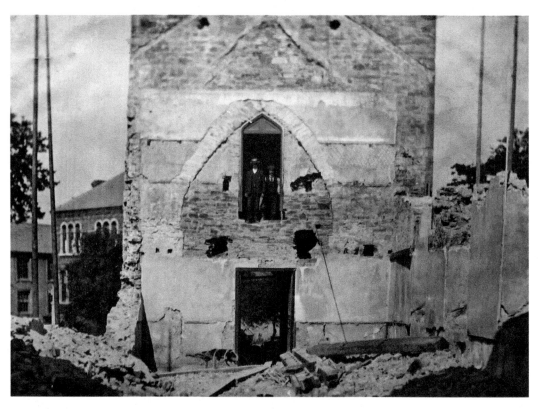

The Church Rebuilding of 1905

With the exception of the clock tower, the whole of the church was demolished and rebuilt in 1905. Access to the tower at the rear interior of the building was improved, as illustrated in the two photographs taken during the reconstruction of the church.

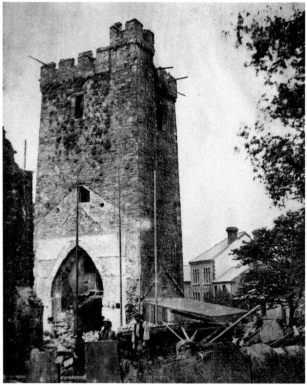

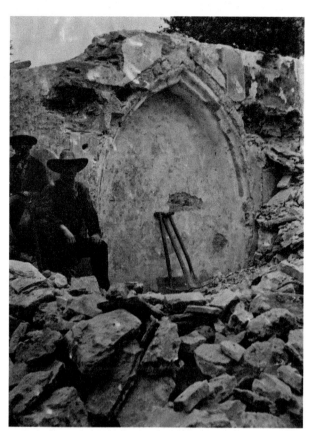

The Church Rebuilding of 1905

The top photograph shows an arch of limestone discovered in the north wall of the chancel of the old church during demolition. At the same time, the memorials were removed from the old chancel to be ultimately re-fixed to the rear interior wall of the tower, as shown in the bottom picture.

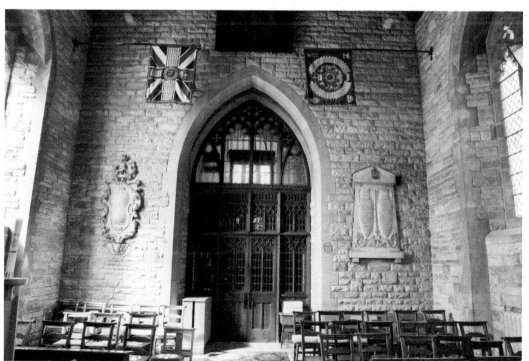

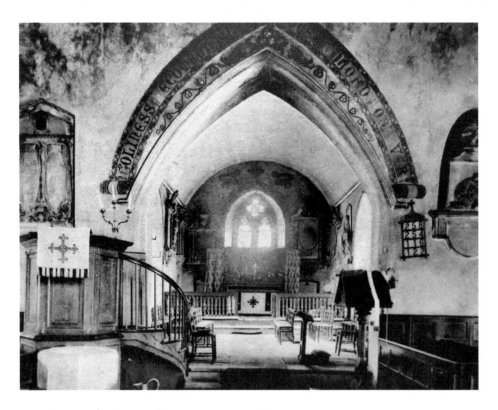

The Church Rebuilding of 1905

Views of the old and new chancels. The three-tiered pulpit and dog altar rail of the old church were replaced during the reconstruction of 1905. The pulpit accommodated the clerk on the lower level, the curate on the middle tier and the vicar on the top. The bars on the dog altar rail were placed so that the farmers' dogs could not get through to the actual altar.

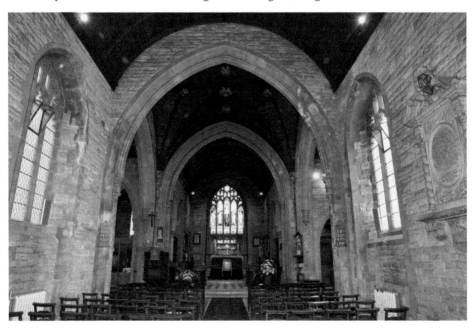

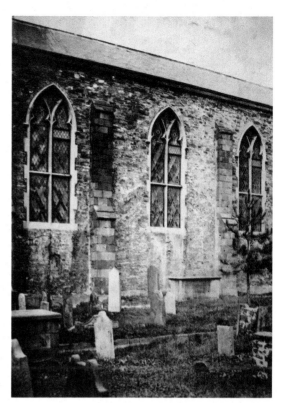

The Church Rebuilding of 1905
The top photograph shows the south wall of the old church, before it was demolished in 1905 to be replaced by the arched entrance depicted in today's view of the same wall.

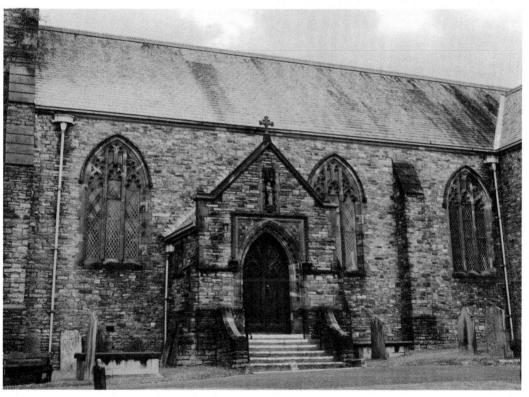

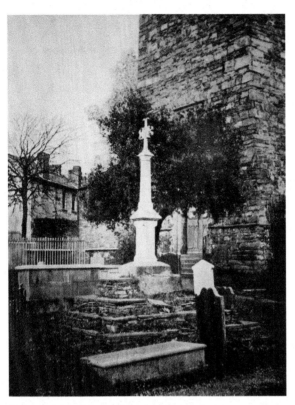

The Parish Church Cross

Taken from John Innes' book *Old Llanelly*, the top picture shows the parish church cross as it was photographed in 1900. As can be observed from today's corresponding photograph, the cross has lost its upper half. The cross, made of Bath stone, was a replacement for the original and dates back to the restoration of 1845, when the ancient steps and cross base were moved.

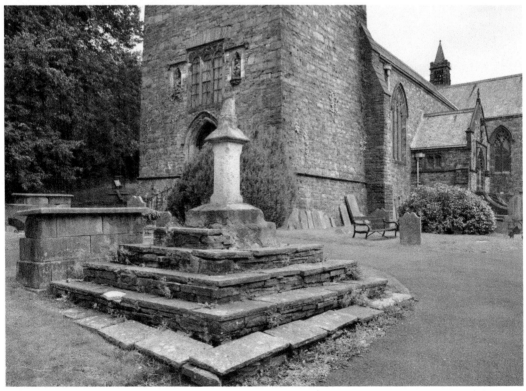

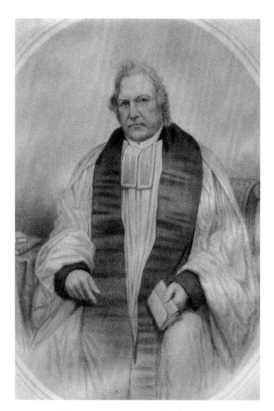

The Clergy

The Revd Ebenezer Morris, one of the more striking figures in the history of the parish, was a very vigorous and controversial vicar of Llanelly from 1819 until his death in 1867 at the age of seventy-seven. It was during his time that a major restoration of the church fabric took place, and the building was rescued from the dilapidation and neglect that had disfigured it for years. His grave is on the right of the path leading to the Lych Gate, just past the tower. The present rector and incumbent is the Revd Canon, Sian Jones, BA.bTh, and she is shown in the accompanying photograph with the Revd Vivian P. Roberts, BD (Surrogate).

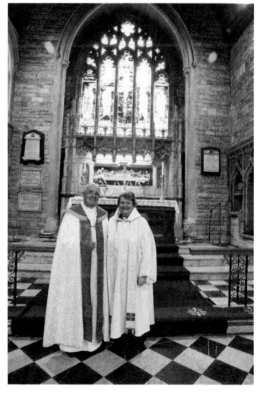

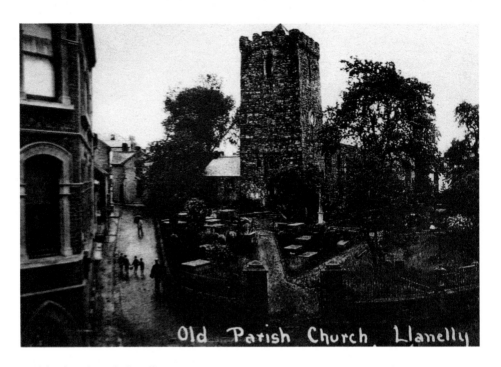

Old Parish Church Llanelly

Parish Church and Llanelly House

The top picture and the corresponding one on the next page together form a panoramic view that embraces both parish church and Llanelly House. As for the view of the church, restoration had yet to take place and the cross was still complete at that time. Due to the tree growth, it is difficult to see in today's lower photograph what changes have taken place to the church. One change that is obvious, however, is that of the Lych Gate, which was erected in 1911.

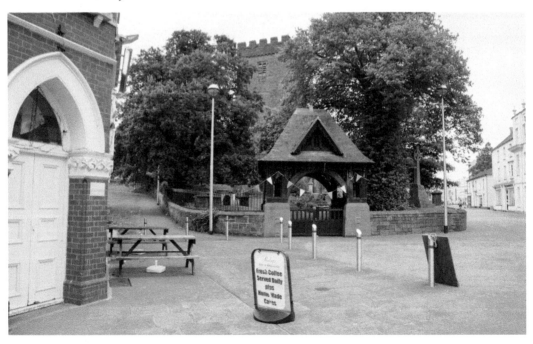

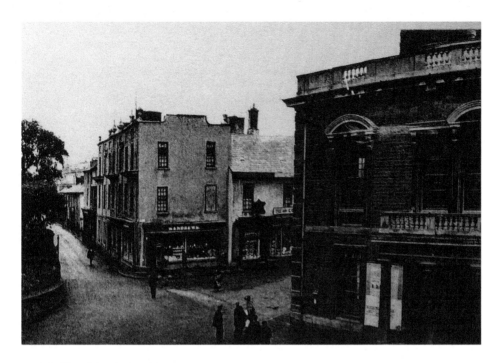

Parish Church and Llanelly House

In 1904, Llanelly House was used as a commercial building with shops occupying the ground floor on two sides of the property; on Bridge Street and Vaughan Street. As can be seen from the lower photograph, both Llanelly House and the Athenaeum and library building have undergone major changes over the last century. Llanelly House has been completely restored to its former glory while the porch, balcony and parapet to the front of the Athenaeum and library building have been removed.

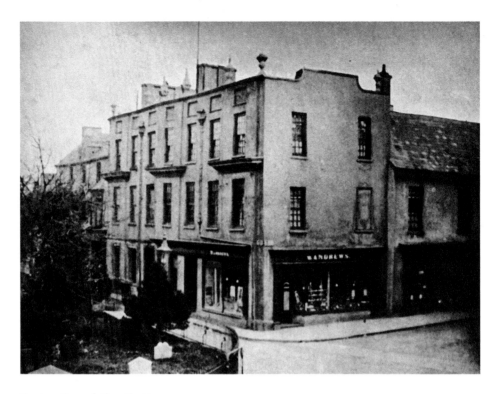

Restoration of Llanelly House

The top picture of Llanelly House appears in John Innes' book *Old Llanelly,* and is dated 1900. At that time, among others, the property was in use as a bonded warehouse by Margrave Bros., wine and spirit merchants, and as confectionary and toy shop at No. 22 & 24 Vaughan Street, by J. Andrews. The bottom photograph shows the house under scaffolding and wraps during its restoration period before 2013.

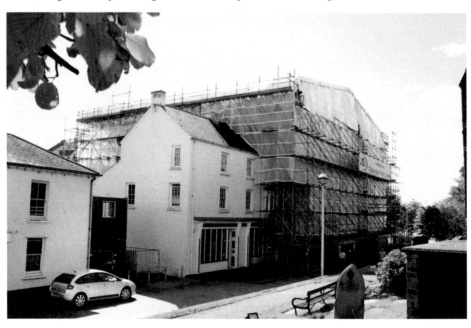

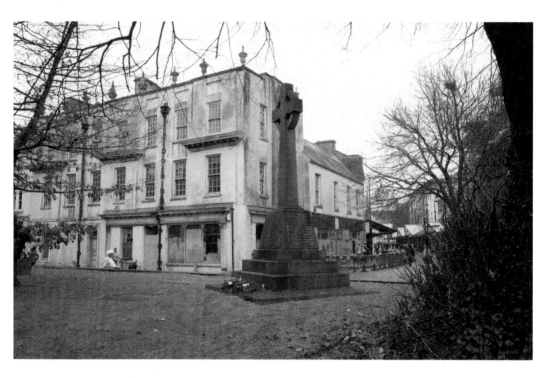

Restoration of Llanelly House
Another view of the corner of Llanelly House, this time from around 2003, when the property rose to national significance as a grand finalist on the BBC *Restoration* programme. The lower photograph was taken in 2012 when restoration work was well under way and Llanelly House was visited by members of the Trostre Works Tata Steel heritage team.

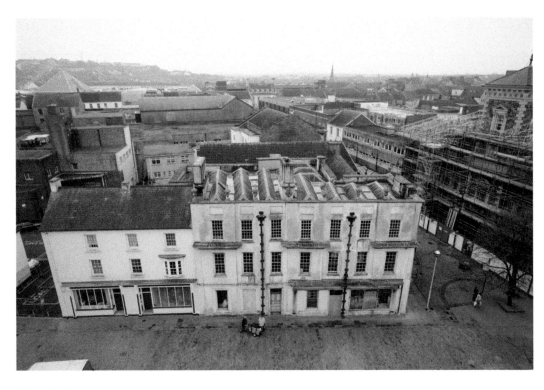

Llanelly House
Contrasting views of Llanelly House in 2011 before the wraps came out and work began, and in August 2014 when the restoration work had been completed.

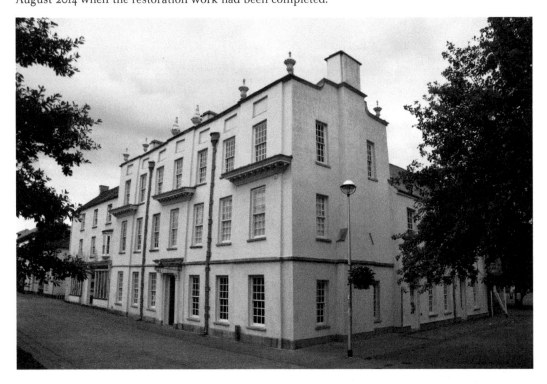

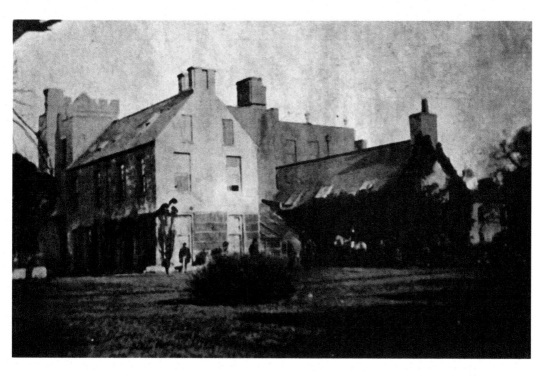

Llanelly House
The side and back views of Llanelly House in 1900 as depicted in John Innes' book *Old Llanelly*. The second photograph illustrates that the gardens have long gone and buildings have now been erected in their place.

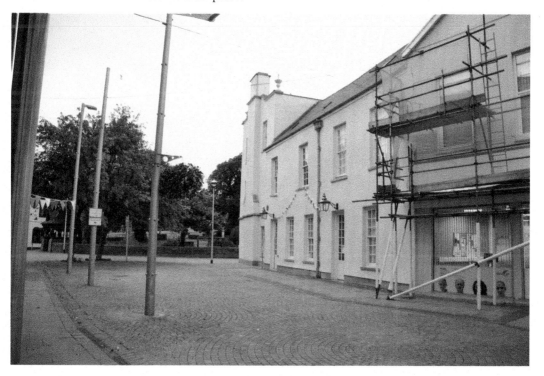

Mira Turner's Bedroom

Mira Turner was head housemaid at Llanelly House. She died in 1851 at the age of twenty-two, after some unacceptable 'goings-on' were revealed in the house. At the inquest, the cause of her death was recorded as temporary insanity: a term used in Victorian times to remove the stigma of suicide. The two photographs show views of Mira's room (where her ghost is said to roam) during restoration and now.

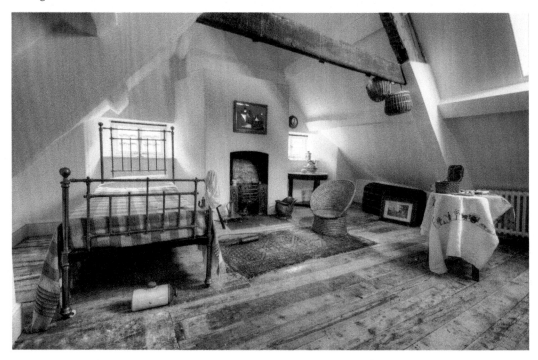

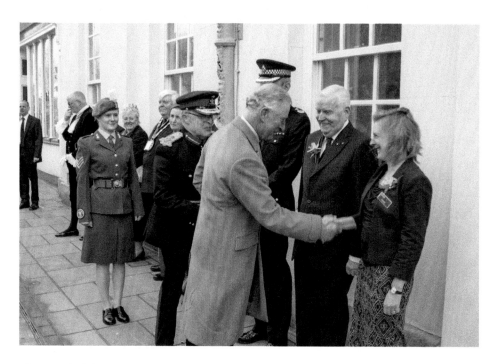

The Royal Visit

Llanelly House, the restoration of which had been completed in 2013, was honoured by a visit of HRH Prince of Wales on 28 February 2014. Among those presented to Prince Charles was Claire Deacon, the chief executive officer of the Carmarthenshire Heritage Regeneration Trust. Using the same prestigious location outside the front of Llanelly House, members of the busy house management team were persuaded to pose for a group photograph in August 2014.

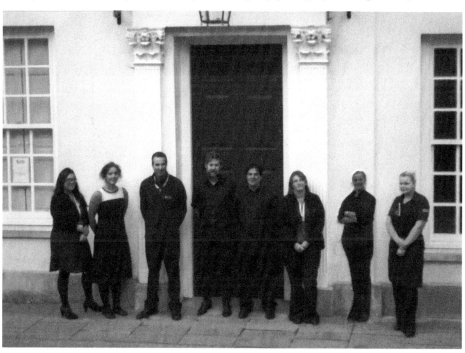

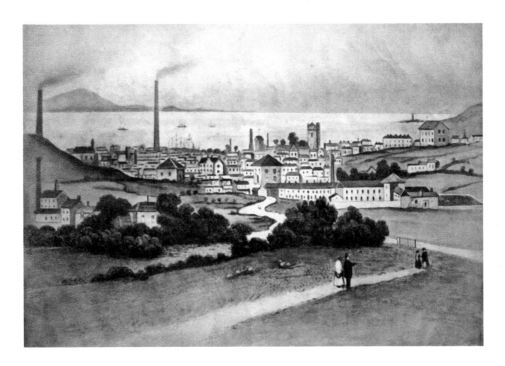

Llanelli in 1854

The view in the top watercolour sketch, is the work of Mrs Havard, the wife of a local Wesleyan minister. The spot she chose from which to prepare her art work in 1854 was probably on Box Hill; the area now covered by the Box Hill Cemetery. Fortunately, we also have the bottom sketch, which was prepared by an anonymous artist, which helps to identify a number of the key buildings that appear in Mrs Havard's painting.

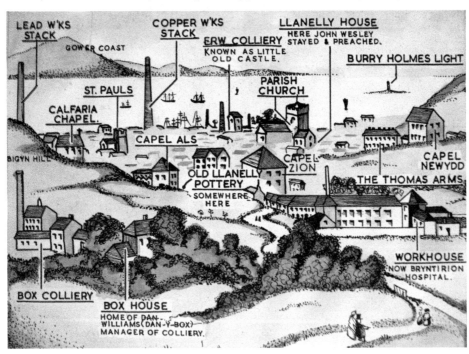

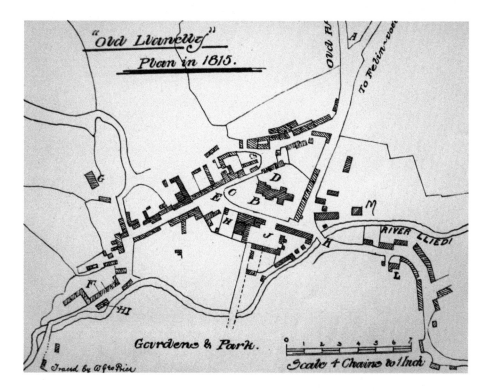

Llanelli in 1815 and 1860

Compare these two maps with the map from 1761 (*reproduced on page 14*) to see how the town of Llanelli began to develop and expand. The map from 1860 is a near reflection of the view of Llanelli, as drawn by Mrs Havard in her 1854 sketch (*reproduced on the previous page*).

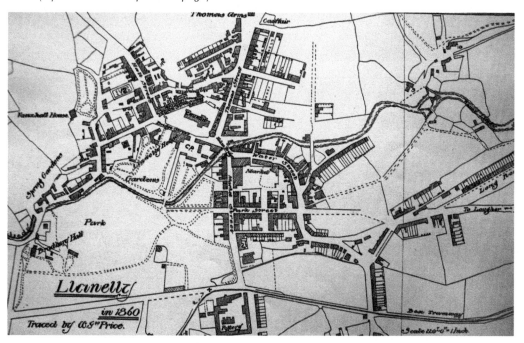

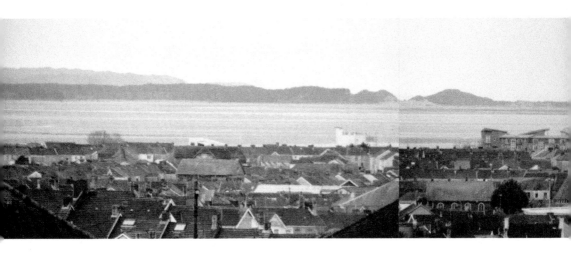

Panoramic View of Llanelli in 2014
The author has attempted, on this page and the next, to reproduce the same panoramic view of Llanelli as that which Mrs Harvard sketched in 1854. In order to pan the same area, the camera was positioned at the highest point in Box Hill Cemetery in order to try and obtain a good depiction of today's Llanelli.

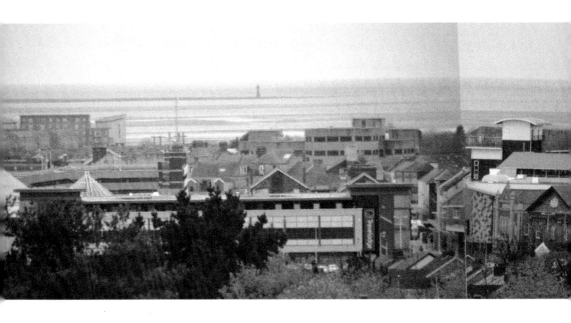

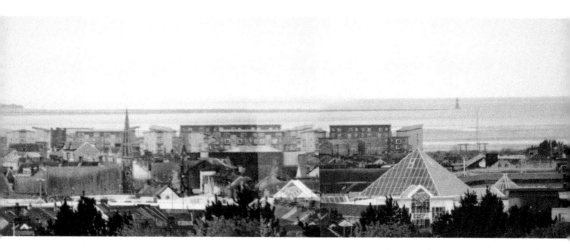

Panoramic View of Llanelli

To appreciate the resulting, but rather disjointed, panoramic view, the four photographs should themselves be viewed from the top left on page 34 through to the top right on page 35, and then from the bottom left on page 34 to the bottom right on page 35. Due to the tree growth and urban expansion of the town, it was not possible to see, identify or photograph all the notable landmarks of Mrs Harvard's sketch.

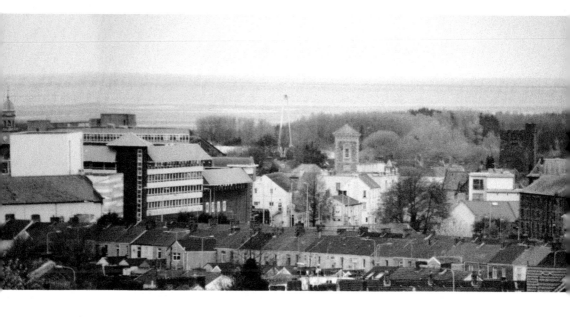

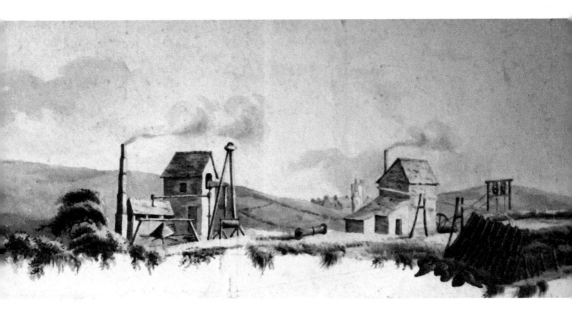

Notable Landmarks

In general, the photographs from now on are arranged to follow (where possible) those landmarks identified in Mrs Harvard's sketch from left to right, starting with box colliery and finishing with the Burry Holmes Light. The top drawing shows the old box colliery on the Swansea Road around 1820. Nothing exists to show the location of this mine today. St Paul's church is another edifice which is no more, having been demolished in the fairly recent past. Only its graveyard remains today to provide a memorial of the church's existence.

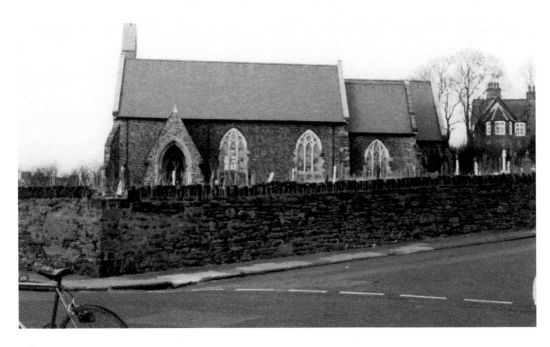

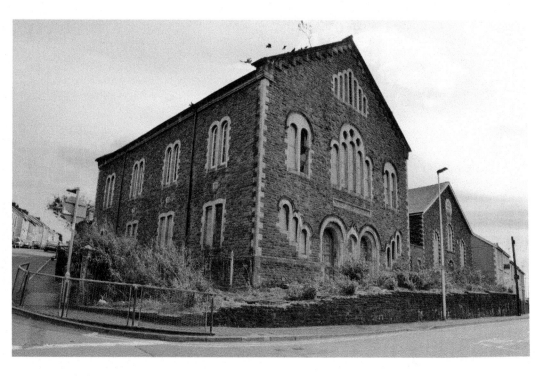

Notable Landmarks

The top photograph shows Calfaria chapel in a very sorry state of disrepair, while Capel Als in the lower photograph is covered with builder's scaffolding and appears to be preparing for a new lease of life.

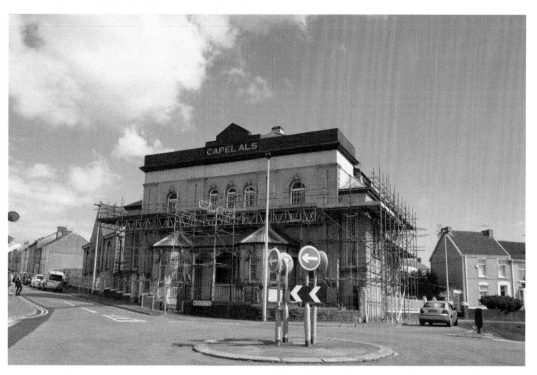

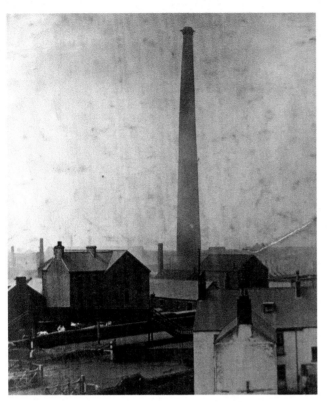

Notable Landmarks

The Llanelly Copper Works, dominated by Bowen's round chimney stack, is shown in the upper picture of 1885. In the mid-nineteenth century, this was the third-largest copper smelting works in the world. Today, the site has been flattened, and there is nothing left to see if one peers over the boundary wall of this once very important works. The wall, and the blue plaque fixed to it, are all that remains to show that it ever existed.

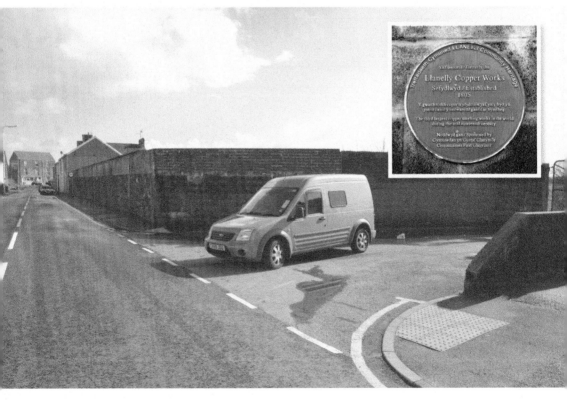

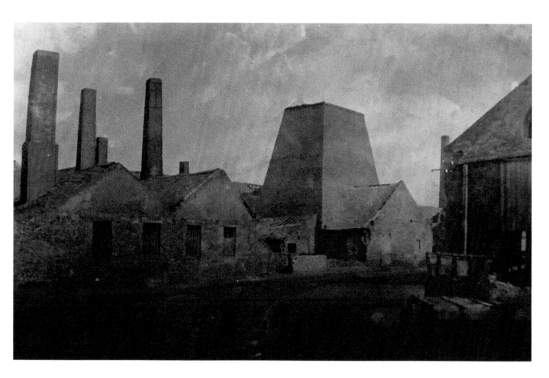

Notable Landmarks

The top photograph takes the viewer inside the old Llanelly copper works, while a further memento of its influence on the town exists in the name of the road on which it once stood: Heol Copper Works, Copperworks Road.

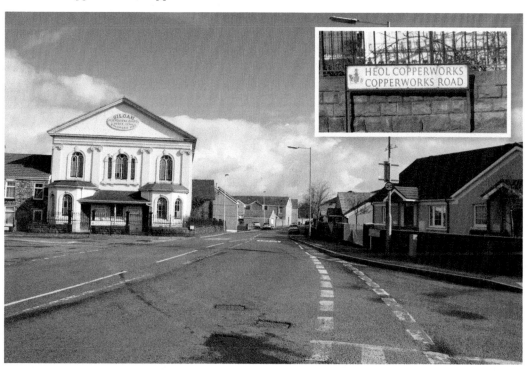

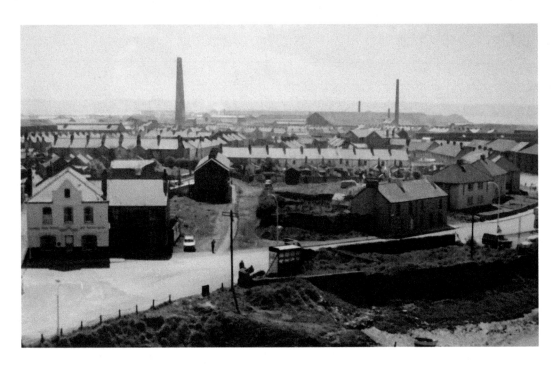

Notable Landmarks, Past and Present

Harold Prescott, Llanelli librarian and man with a view to looking to the future to preserve the past, took the top photograph in 1971. It was possibly taken from the top of the old hydraulic accumulator water tower (now the Sosban restaurant). The picture takes in the view of the Hope and Anchor public house on Cambrian Street, Railway Place and the copper works beyond. The bottom photograph attempts to capture the same scene in 2014, but was taken from a lower perspective.

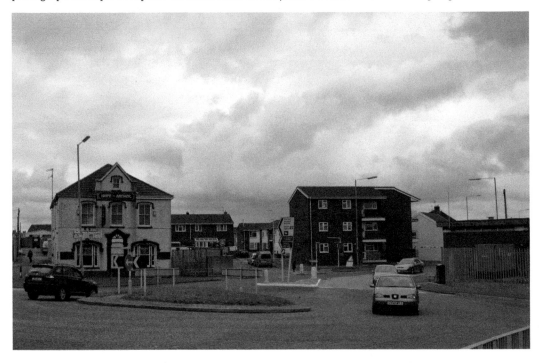

Notable Landmarks, Past and Present
The top photograph of the Hope and Anchor, on the junction of Cambrian Street and Railway Place, was again taken in 1971. The lower photograph reflects current social trends, with the public house closed and up for sale.

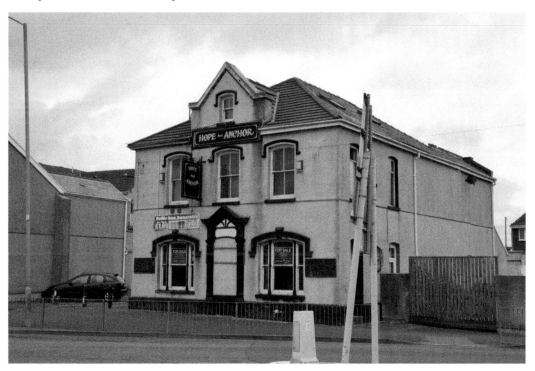

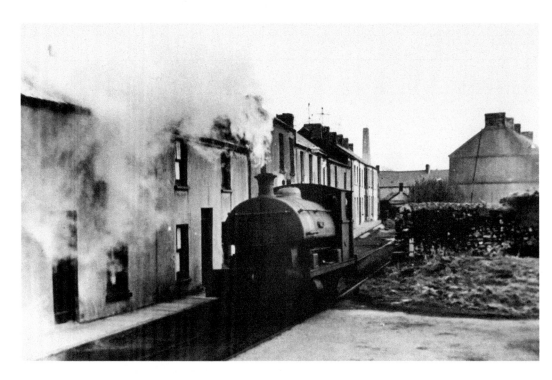

Notable Landmarks

A very popular photograph of the copper works' saddle tank railway engine travelling along the track in front of Railway Place. A very appropriate name, but an event of the past. Both engine and rails have long gone, and Railway Place is now a peaceful little cul-de-sac.

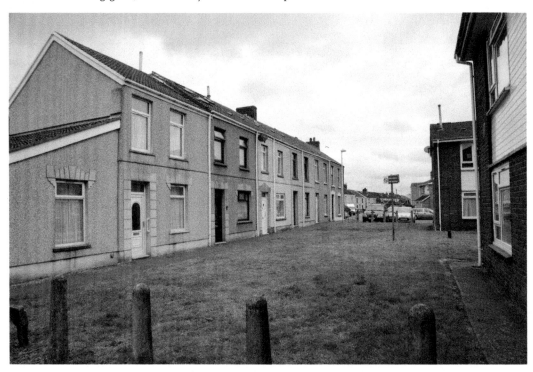

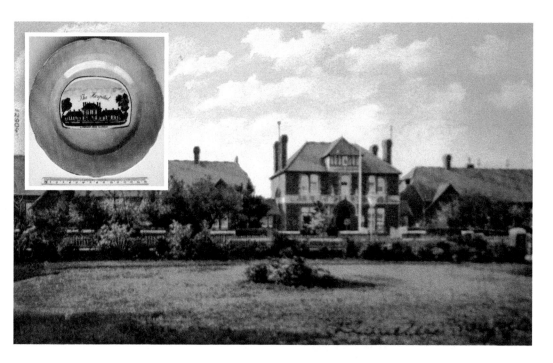

Notable Landmarks

The top postcard is date stamped 4 April 1905, and shows the old Llanelli general hospital located on the top of the hill at Marble Hall Road. A similar picture has been captured on the Crestware Style Plate, shown in the inset. The hospital was opened in November 1885 and remained in service until 1990, when the new Prince Philip hospital was opened in Bryngwynmawr. The main entrance building of the old Llanelli general hospital has been preserved as private accommodation, matching the housing development around it.

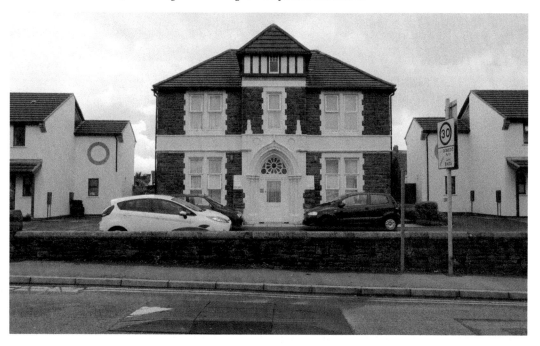

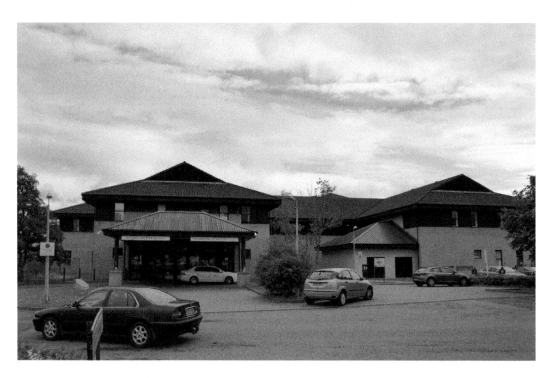

Notable Landmarks

The new Prince Philip hospital at Bryngwynmawr was opened on 15 May 1990, surrounded by a lot of local controversy and opposition to its actual naming. The opening, however, was nevertheless recorded with the issue of a special commemorative plate.

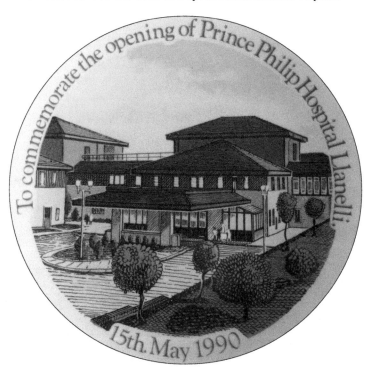

To commemorate the opening of Prince Philip Hospital Llanelli.
15th. May 1990

Notable Landmarks

The map shows the extent of the St Elli shopping centre, located in the heart of Llanelli. Since its opening in 1997, the centre has become a defining landmark in the town. Located where the Llanelly Pottery once stood, the centre covers an area of 160,000 square feet and offers 450 car park spaces.

45

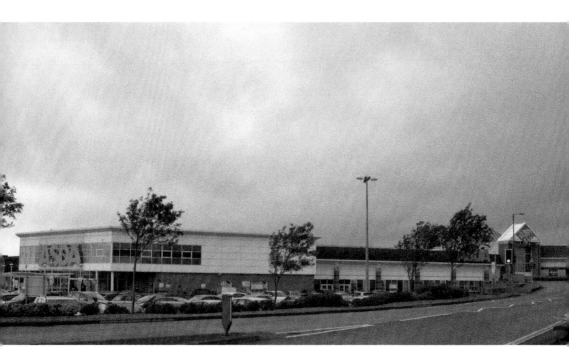

Notable Landmarks

The St Elli shopping centre, which is located in the centre of Llanelli's shopping area and benefits from a footfall of approximately 135,000 people per week, is anchored by a 70,000-sq ft Asda supermarket. Other than a blue plaque fixed on the outside wall of Asda, all we have left to remind us of the once famous pottery, is Pottery Street and Pottery Place, which are separated from the centre by Upper Robinson Street.

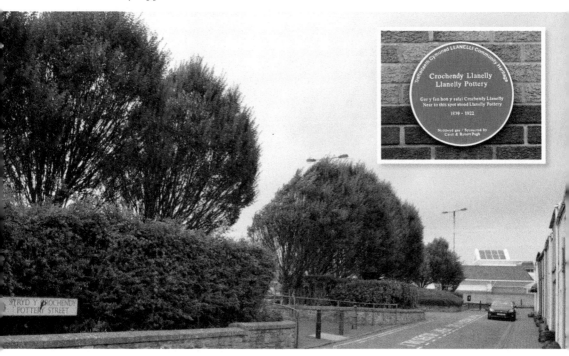

Notable Landmarks

Tŷr Ynys; Island House. This unusual irregular five-sided public house, with its white and black Tudor style decoration, is reminiscent of Shakespeare's Globe Theatre in London. Protests fell on deaf ears, and Island House was eventually demolished to make way for the new bus terminal of the Llanelli East Gate scheme.

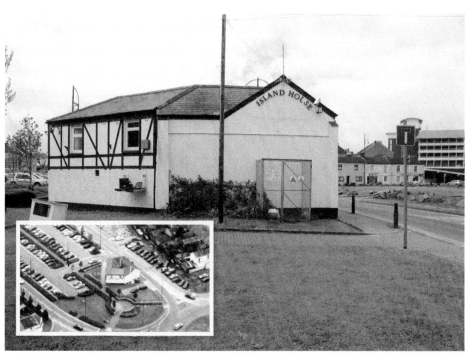

Chapel Zion. Llanelly.

The Wrench Series, No. 8790

Notable Landmarks

Park Street School was demolished around 1976. Now that Llanelli's East Gate scheme is complete, it is difficult to visualise where it once stood alongside Zion Baptist chapel.

The Llanelli East Gate Scheme

Taken in 2010, the top photograph shows the two Zion Baptist chapels standing alone, after the original Stepney Hotel had been demolished and prior to the start of Llanelli's East Gate Scheme. The lower photograph shows the same scene in August 2014.

The Llanelli East Gate Scheme
Receiving planning approval in July 2010, the East Gate Scheme was a redevelopment of 5 acres of Llanelli's town centre, and was constructed in phases until final completion was achieved in January 2013. The two photographs looking across Stepney Place were respectively taken in 2012 and 2014.

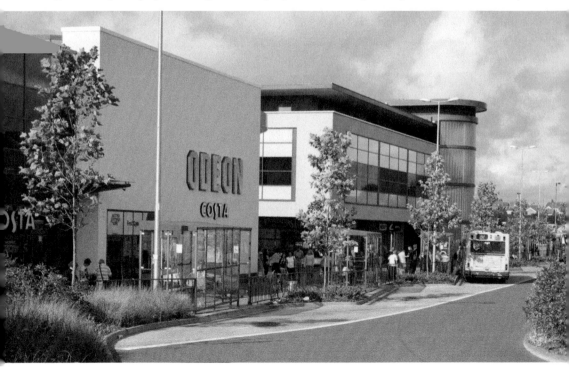

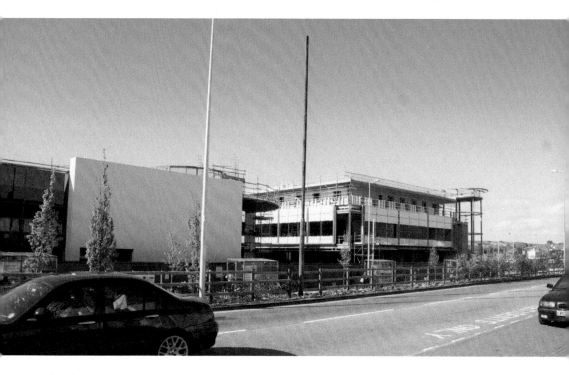

The Llanelli East Gate Scheme
The East Gate Scheme embraces a total area of around 95,000 square feet for leisure, retail and office accommodation. This includes a five-screen Odeon cinema, a fifty-three-bed Travelodge, and 22,000 square feet allocated for restaurant areas.

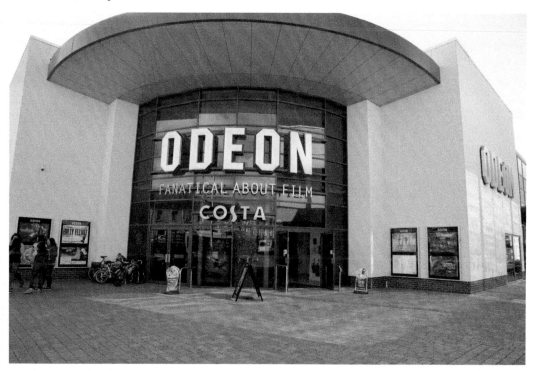

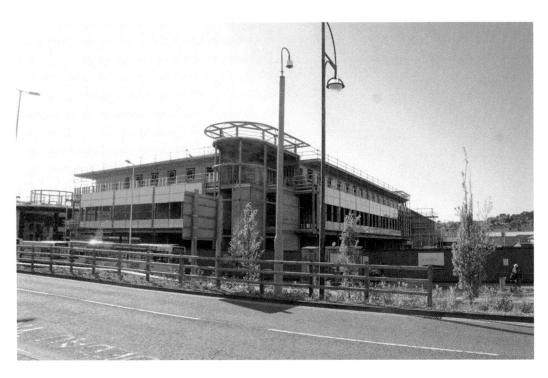

The Llanelli East Gate Scheme
Comparison views of the main frontage of the East Gate Travelodge building, taken in 2012 and 2014. Of the total office space, 21,000 square feet was allocated for the exclusive use of Carmarthenshire County Council.

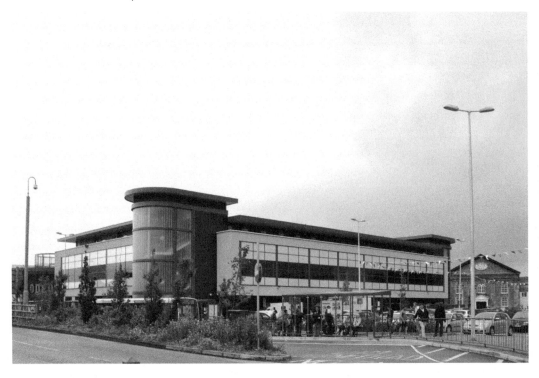

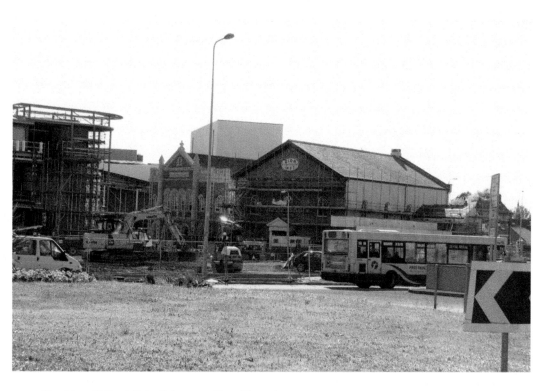

The Llanelli East Gate Scheme – Zion Chapel
The first Zion Baptist chapel (1857) undergoing refurbishment in 2012 during the construction stages of the East Gate Scheme, and after completion of the latter in August 2014.

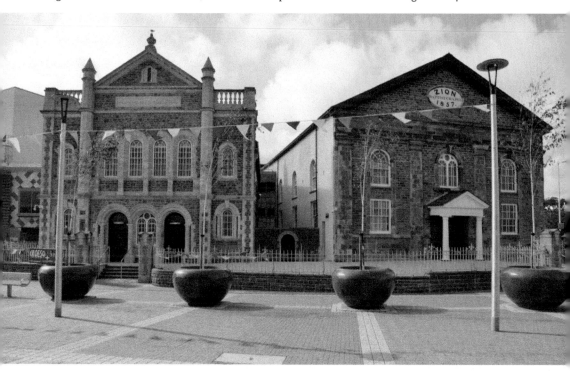

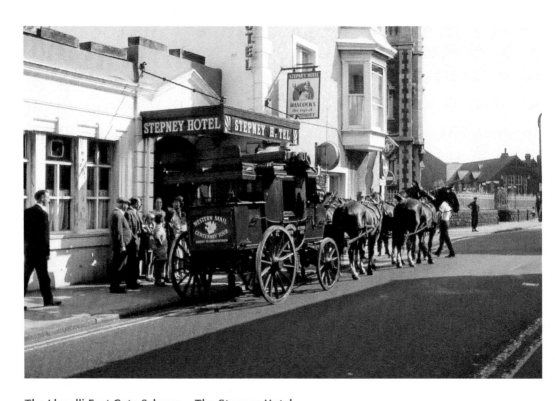

The Llanelli East Gate Scheme – The Stepney Hotel
Arriving in style with the Royal Mail coach at the old Stepney Hotel, before it was demolished and replaced by the ultra-modern building housing The Ffwrnes Theatre.

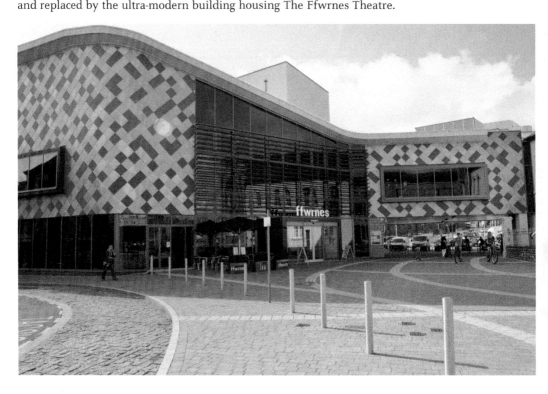

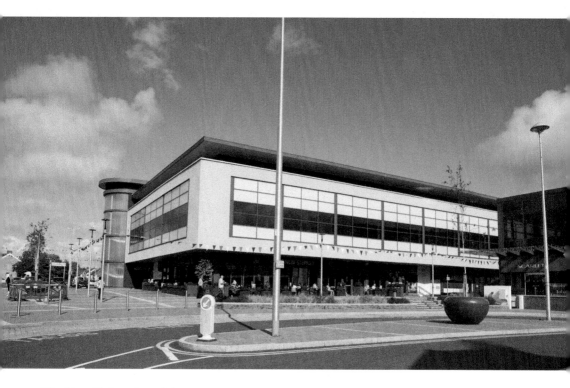

The Llanelli East Gate Scheme
Views of The New Stepney Hotel (top photograph) and the five-screen Odeon cinema constructed under the East Gate Scheme.

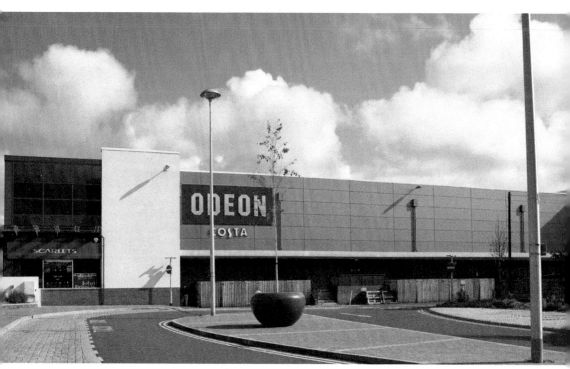

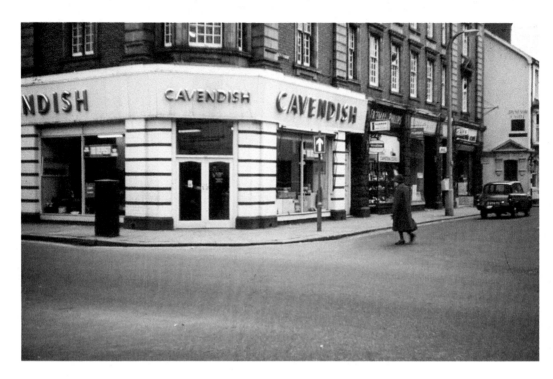

Park Street

The majestic Exchange building on the corner of Park and Market Streets. It is only the occupant of the ground floor that rings the changes from the well-known Cavendish furniture store to the present-day Avo café & wine bar.

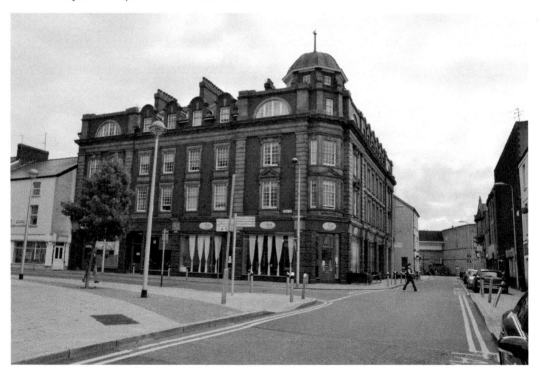

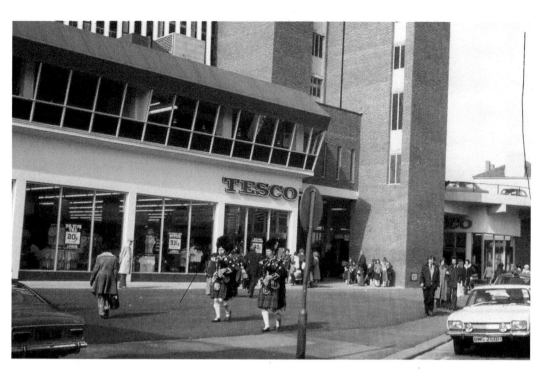

Park Street

Negotiations had begun in 1976, but it was not until 1979 that the grand opening of the new Tesco supermarket took place, accompanied by two Highland pipers. The superstore eventually moved to the out-of-town shopping centre at Parc Trostre retail park in 1989, and the building was eventually taken over by the television company Tinopolis.

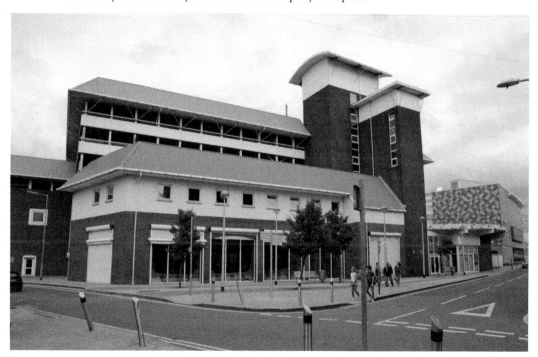

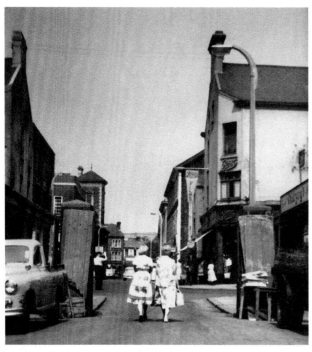

Vaughan Street
Looking down Vaughan Street towards the library, from what is now the covered walkway of the St Elli shopping arcade. Note the policeman on point duty at the junction of where Vaughan Street and Stepney Street cross.

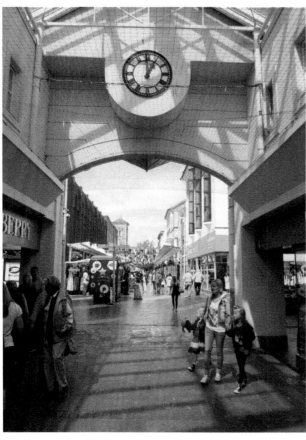

Vaughan Street
Views looking down Vaughan Street towards the library in 2001 and 2014.

The Market and St Elli Shopping Centre
The old entrance to the market from Stepney Street and the entrance to the St Elli shopping centre and arcade.

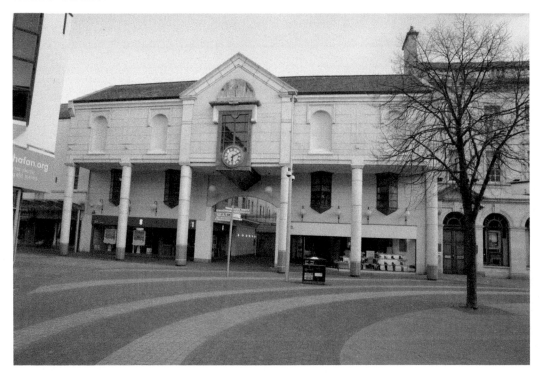

The Market and St Elli Shopping Centre
The entrance to the market from inside the St Elli shopping centre and arcade.

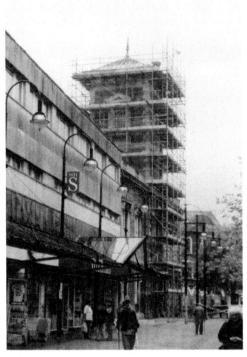

The Athenaeum and Public Library

The tower of the Athenaeum under scaffolding wraps during refurbishment in 2001, and as it is today viewed from Vaughan Street. The Athenaeum, one of Llanelli's oldest buildings, was built in the 1850s and had extensive protection work carried out on it in 2010, during a £3.5 million library refurbishment.

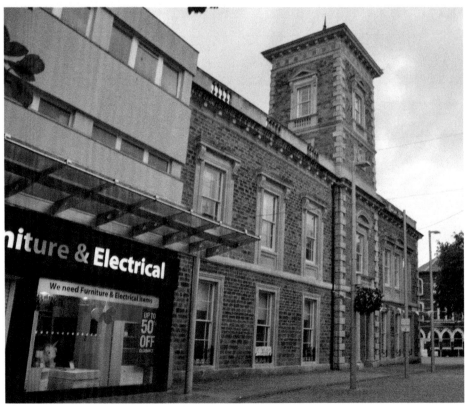

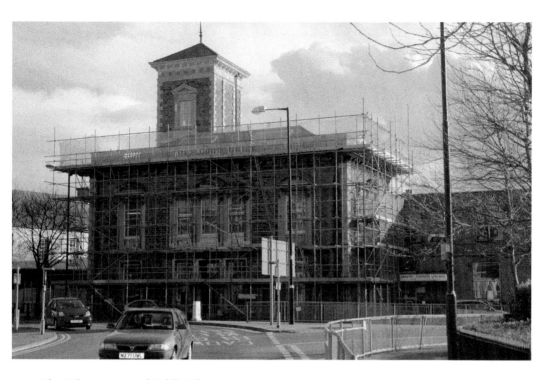

The Athenaeum and Public Library
The Athenaeum, as viewed from Hall Street while under scaffolding wraps, this time during refurbishment in 2008 and as it is today. The plaque shown in the inset records that the Revd John Wesley preached from this spot on numerous occasions.

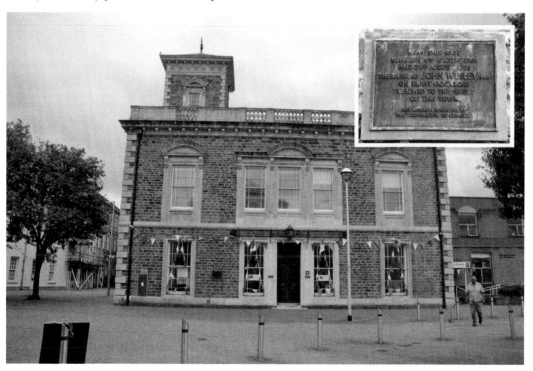

The Red Apple
Closed and boarded up in the top photograph from 2001, and currently called the Red Apple, this characteristic building on the corner of Hall Street and Bridge Street has frequently changed hands over the years.

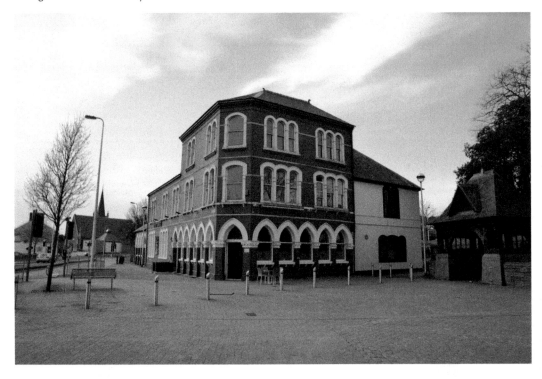

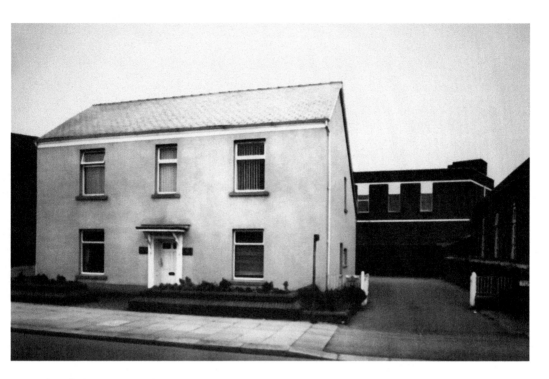

Llanelli Town Council
The top photograph shows the old vicarage before it was taken over by the newly formed Llanelli Town Council as council offices in 1974. The lower photograph was taken of the extended building in August 2014, when it was decorated for the National Eisteddfod and with the mayor and mayoress of Llanelli Town Council, Cllrs Roger and Ruth Price, standing outside.

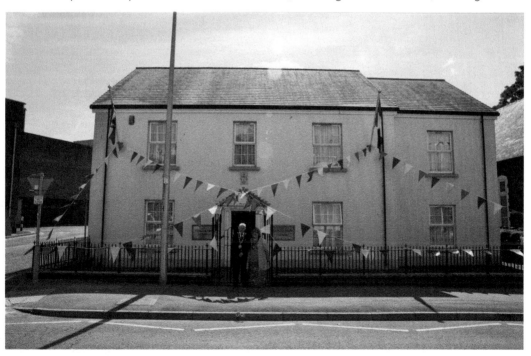

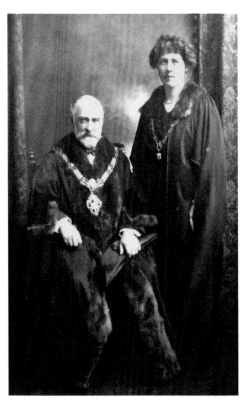

Llanelli Town Council

Around 100 years apart, the top picture is of Sir Stafford Howard, KCB, and Lady Meriel Howard, mayor and mayoress of Llanelly Urban District Council 1915/16. Sir Stafford (1851–1916) was the first charter mayor in 1913/14, and served again in 1914/15. In contrast, the lower photograph is of the mayor and mayoress of Llanelli Town Council for the current year 2014/15, Cllrs Roger and Ruth Price.

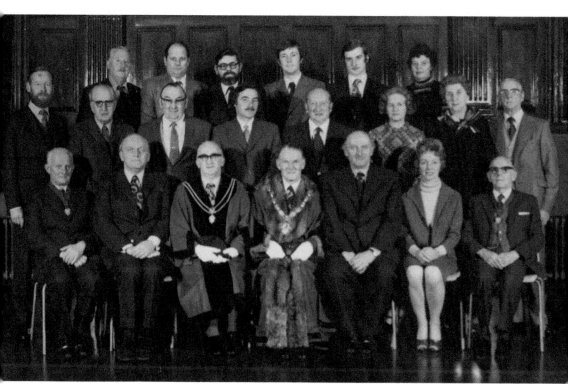

Llanelli Town Council

The group photograph is of all the members of the council following the inauguration of the new Llanelly Town Council in 1974. The bottom picture, taken in the council chambers, is of the mayor of Llanelli, Cllr Roger Price, the deputy mayor, Cllr Winston Lemon, and town clerk, Mel Edwards, BA, PhD, MBA. This picture also illustrates both the town coat of arms and the mace.

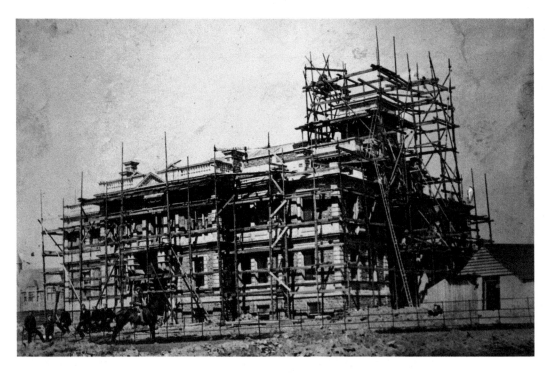

Llanelli Town Hall

The magnificent town hall in Llanelli is in a neo-Jacobean style, and was built to a design by William Griffiths. The top photograph shows it under construction in 1895, while the bottom photograph, taken from the same viewpoint, captures the town hall as it is today.

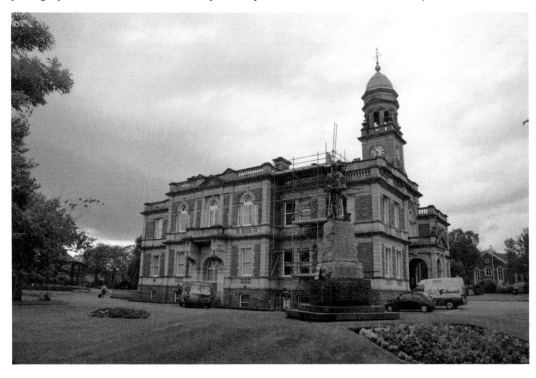

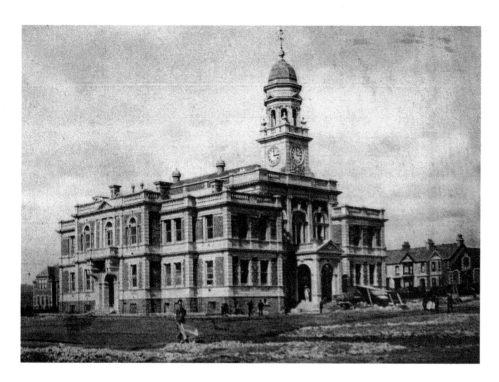

Llanelli Town Hall
The completed town hall in 1896 is illustrated in the top picture, while as a contrast, the lower modern view of the town hall has been taken from the rear of the building to illustrate its all-round splendour.

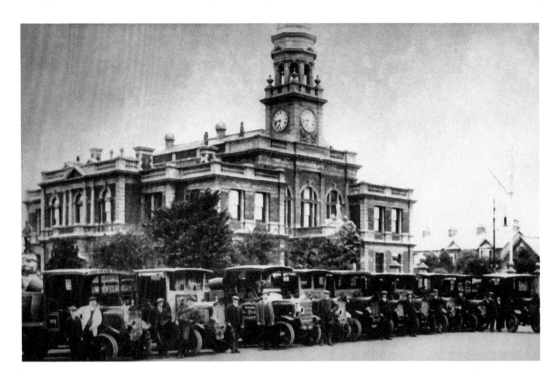

Llanelli Town Hall

The top photograph is a publicity shot, taken around 1910 in front of the town hall by Buckley Bros. Llanelly Brewery to show off their impressive range of vehicles. The oblique view below was taken from the roof of the adjoining Tŷ Elwyn building in July 2014.

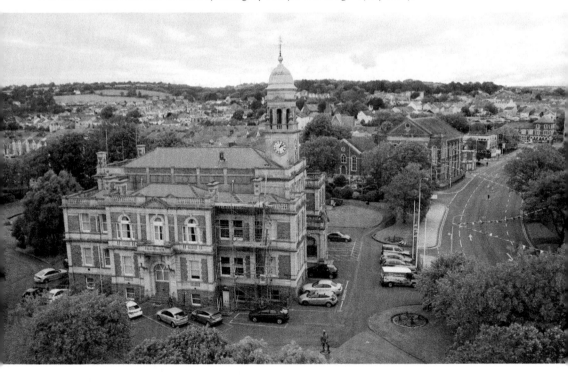

Town Views

Mervyn Rees, 1899–1980, was born and bred in Llanelli. He started his career in the iron and steel industry as a metallurgist, and was employed in the old Llanelly Steelworks from 1913 until the 1930s. From there, he progressed to being a professional photographer with his own studio at No. 26b Cowel Street, in the old bank chambers on the corner of Stepney Street. Mervyn specialised in portrait photography, but he also took photographs of industry and town scenes. It is the latter that have been produced here, together with modern compatible views taken from the top of the illustrated Tŷ Elwyn building.

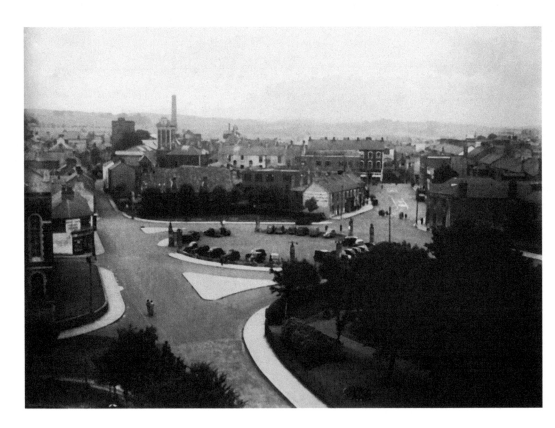

Town Views

Mervyn Rees took the two oblique views reproduced on these two pages from a vantage point high in the clock tower of the town hall. Unfortunately, access to the clock tower is now restricted, and an attempt has been made to take corresponding views from the roof of the adjoining Tŷ Elwyn building. Taken in the 1930s, Mervyn's first picture is directed north-east, looking out over the Bull Ring to the Athenaeum and down Stepney Street. Due to urban development and tree growth, it is difficult to distinguish many of the older features in today's photograph.

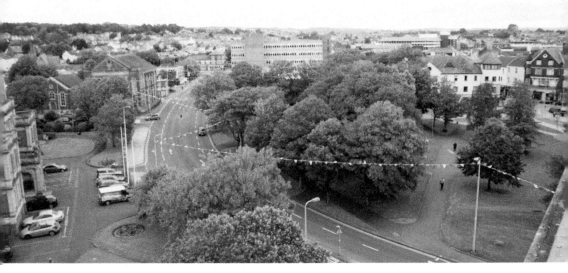

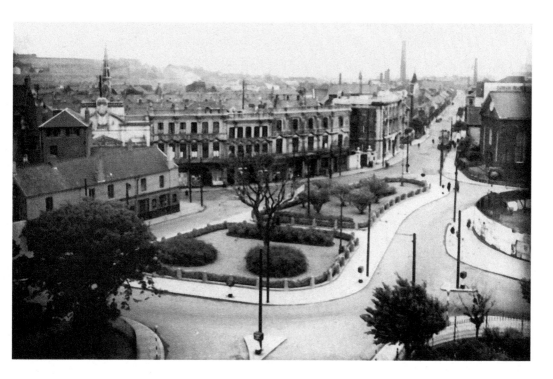

Town Views

The second of Mervyn's oblique photographs is taken overlooking the new town hall square traffic roundabout, built in 1939, and on to Station Road. The current photograph, taken from approximately the same height in the Tŷ Elwyn building, illustrates that further development of the area has been subsequently carried out over the years to try and cater for the ever-increasing traffic demands.

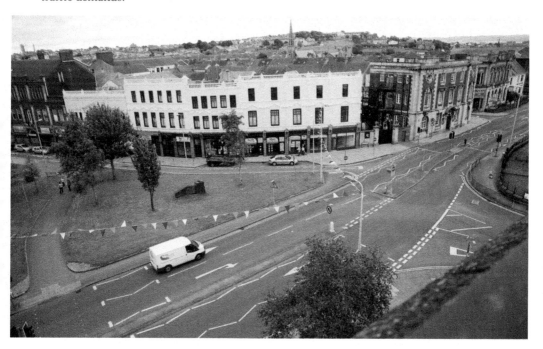

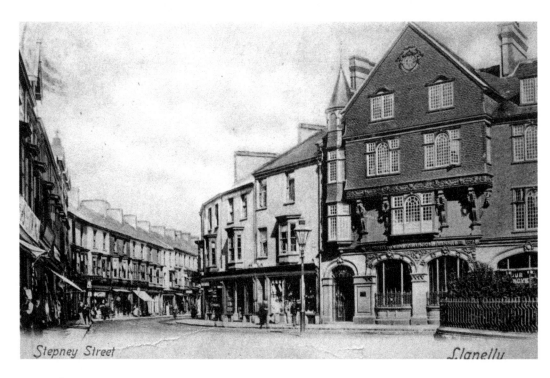

Stepney Street Llanelly

Town Views

Views looking down Stepney Street in the early 1900s and today. The studio of portrait photographer Mervyn Rees was in the old bank chambers, Cowel Street. This is the red-brick building directly to the front in the photographs.

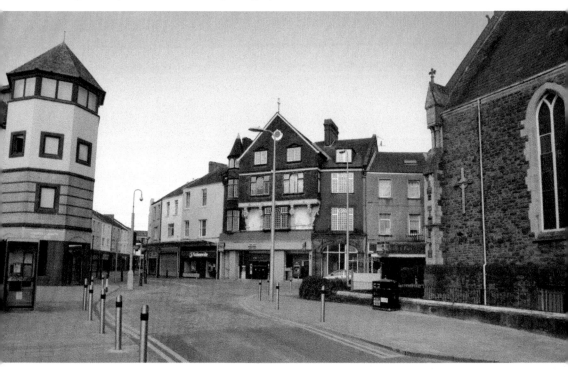

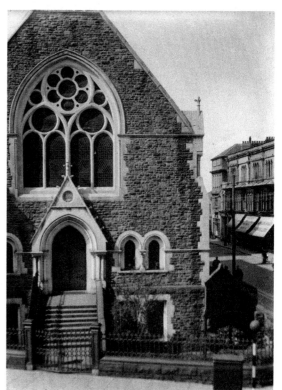

Town Views

Another one of Mervyn Rees'
photographs, taken of the Presbyterian
church on the opposite corner of Cowel
Street. Interestingly though, it shows
the buildings in Stepney Street that
were subsequently demolished in 1939
as part of the town hall square traffic
rearrangements. Today's corresponding
view of the church gives a clear view of
the Tŷ Elwyn building.

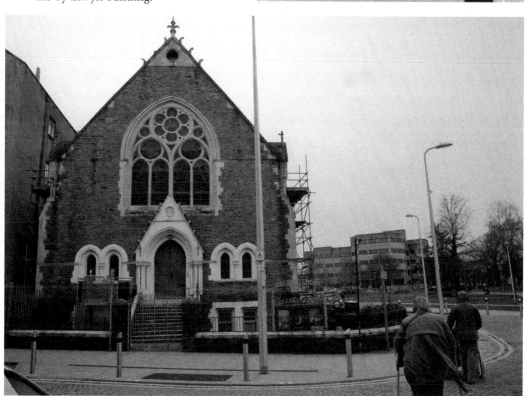

North Dock Accumulator Tower

The iconic Accumulator Tower, known locally as the hydraulic tower, was built between 1897 and 1902, by Sir Alexander Rendel and Partners. Used to operate the hydraulic lock gates at North Dock, the complete complex, consisting of the engine house, tower, boiler house and maintenance buildings, would be used to accumulate water in the tower in order to power the lock gates and other dockside equipment. The photographs show the Accumulator Tower and buildings before and after restoration as the Sosban restaurant, in 2001 and 2014 respectively.

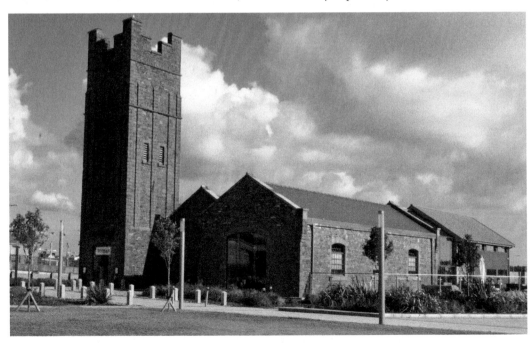

North Dock Accumulator Tower
The top photograph, taken in 2001, shows the inside of the Accumulator Tower and the water cylinder that contained the head of water to provide the required hydraulic power. The Accumulator Tower and building complex has been tastefully restored, and now houses the fashionable Sosban restaurant. The water cylinder itself has been used as a feature in the entrance lobby to the restaurant.

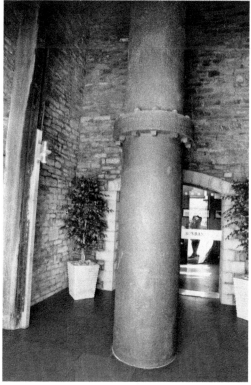

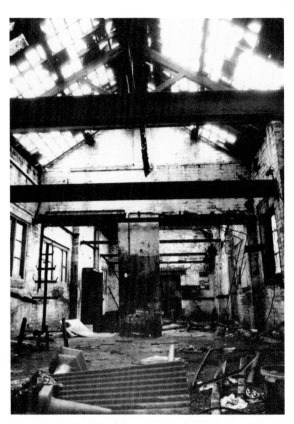

North Dock Accumulator Tower
The chaotic scene inside the
Accumulator Tower building in
2001 before restoration took place,
in comparison with the modern
photograph of the spacious
Sosban restaurant.

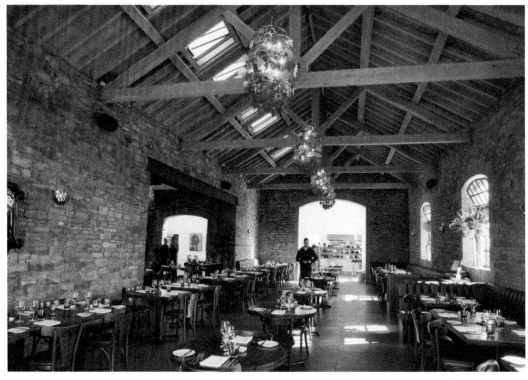

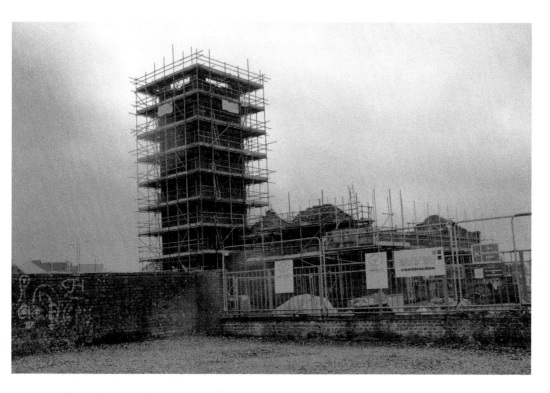

North Dock Accumulator Tower
The Accumulator Tower, dressed in scaffolding while undergoing restoration in June 2001, and the management and staff of today's highly successful Sosban restaurant.

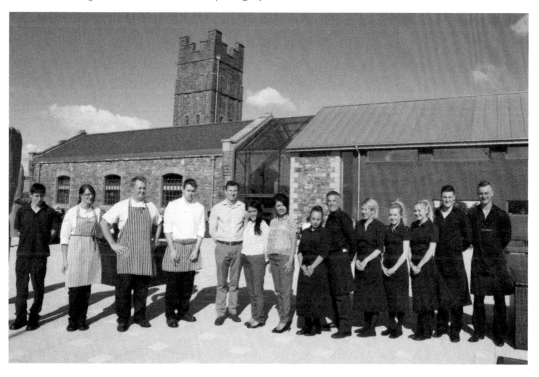

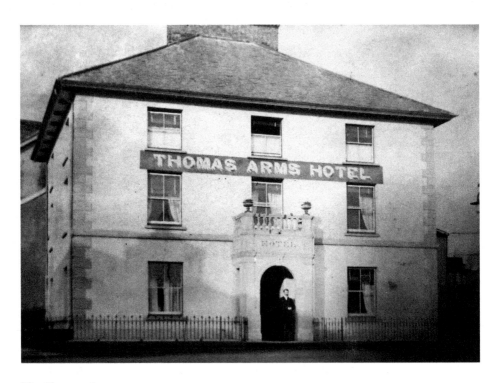

The Thomas Arms

This building would have been one of the landmarks that Mrs Harvard would have recognised for her sketch of 1854 (*see page 32*). In comparing the two photographs, very little appears to have changed over the ages except to the alteration of the entrance, and the change of name on the front of the building from Thomas Arms Hotel to The Thomas Arms.

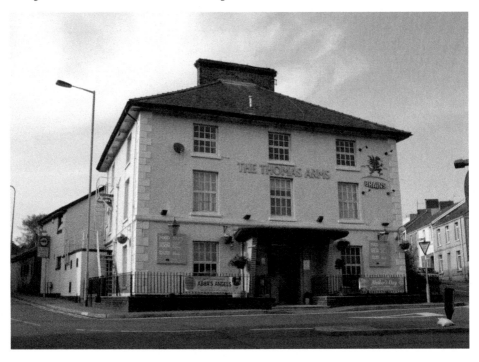

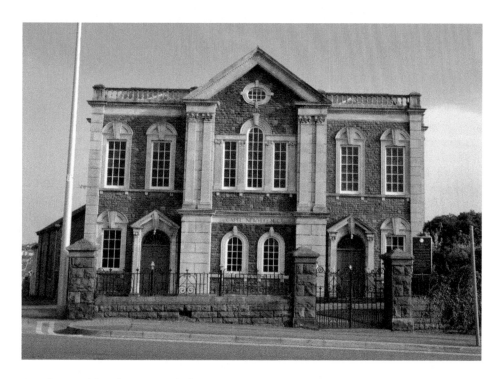

Capel Newydd and Parc Howard

One of the westerly landmarks of Mrs Harvard's sketch (*see page 32*), Capel Newydd, shown in the top photograph, would have certainly stood out proud on the horizon in 1854. As for Parc Howard, it was built around 1834 as Bryncaerau, but it would have been too far over on Mrs Harvard's right-hand side to have appeared in her sketch.

Llanelli Rugby Football
Featured in the top picture is industrialist H. R. Thomas, who claimed to be the man who introduced rugby football to Llanelli as early as 1872. He also claimed to have paid for the purpose-built 'Oval' in People's Park, in which early knockabout games were played. Serendipity took a hand in that the author happened to be passing the new ground when the Parc y Scarlets sign was being installed in October 2008.

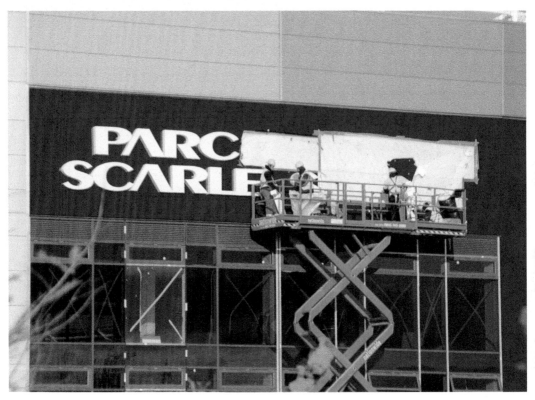

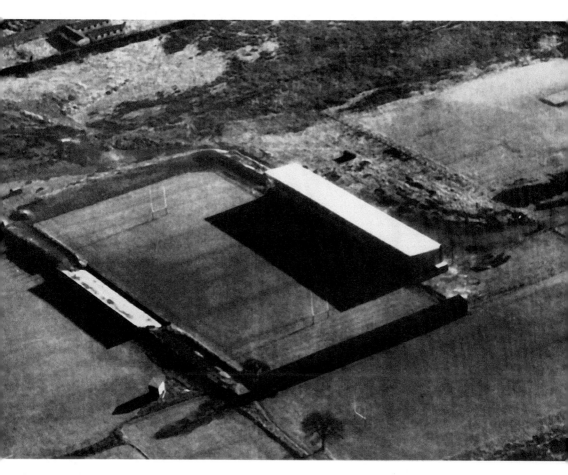

Llanelli Rugby Football
The old and the new aerial views of the famous Stradey Park RFC ground (*above*) in the 1930s, and the new and equally famous Parc y Scarlets RFC ground in 2014.

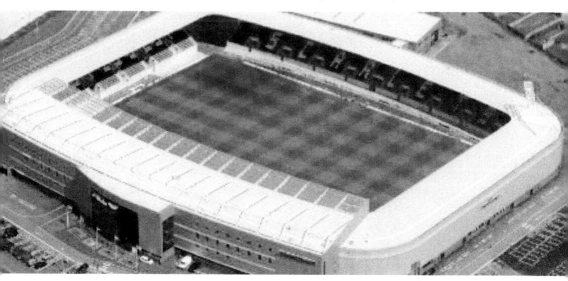

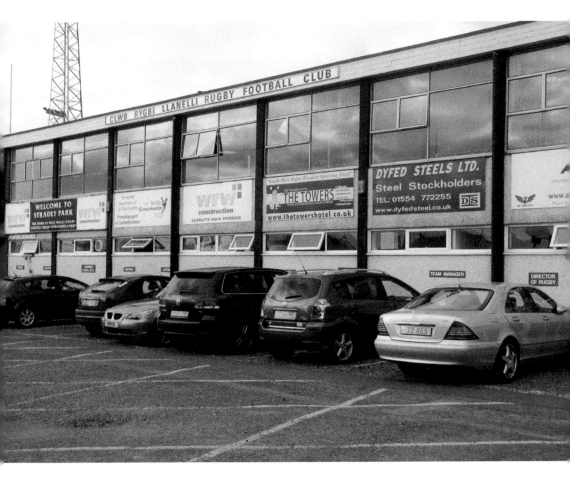

Llanelli Rugby Football

Two contrasting views: the main entrance to the old Stradey Park RFC ground in the 1990s, and the imposing main entrance of the new Parc y Scarlets stadium in August 2014.

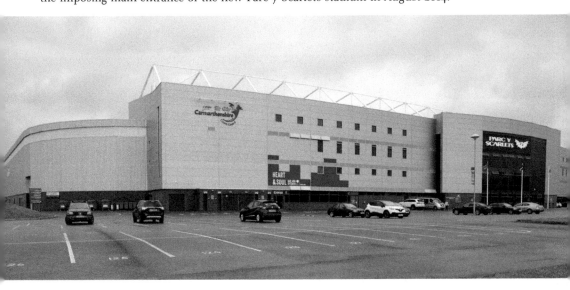

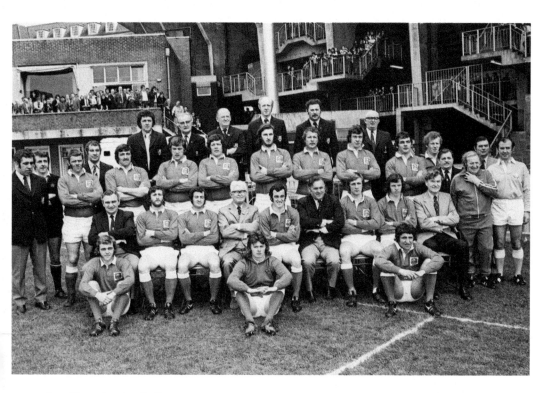

Llanelli Rugby Football

The Scarlets. The top photograph is of the Scarlets team that played Aberavon in 1975. The second photograph shows the Scarlets team of the 2013/14 season.

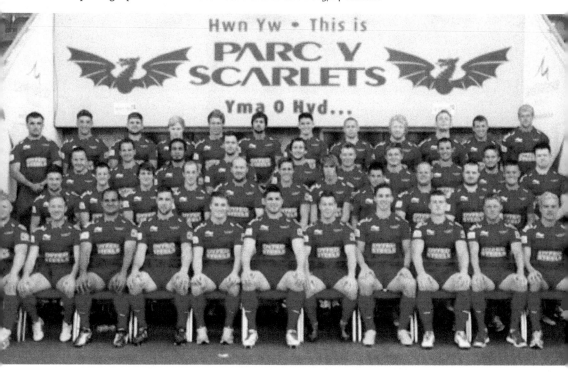

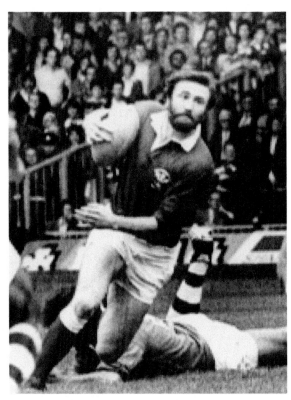

Llanelli Rugby Football
Ray Gravell in action on the pitch, and the 'great man' captured for all time in bronze outside the Parc y Scarlets stadium.

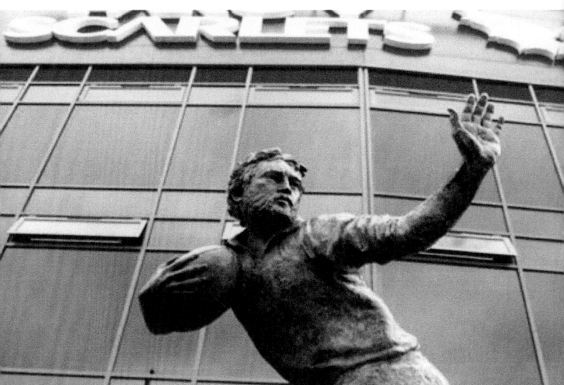

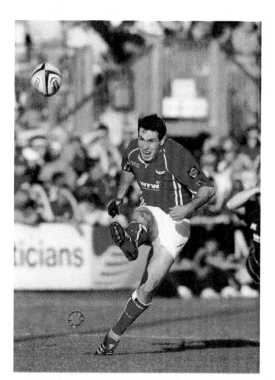

Llanelli Rugby Football
Stephen Jones has achieved fame both on and off the rugby field. The top picture shows him at his best – kicking goals. The second photograph shows a very pleased Stephen Jones, this time receiving an accolade on another field, the Maes, when he was welcomed into the Gorsedd of Bards at the National Eisteddfod of Wales at Llanelli in August 2014.

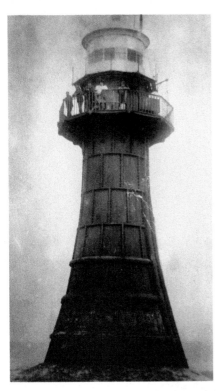

Burry Holms Light

The last of the landmarks highlighted in Mrs
Harvard's sketch of 1854 (*see page 32*), is
the unusual cast-iron lighthouse at Whitford
(Whiteford) Point, which is located in the Burry
Inlet, just off the North Gower coast. The rare
picture captures a visit made to the lighthouse
by Lady Howard Stepney (1876–1952) before
1926, when the lighthouse was deactivated. The
gentleman on Lady Stepney's right in the close-up
is William Thomas (possibly one of the two
keepers), the great-grandfather of Cllr Roger Price,
the current mayor of Llanelli (2014/15).

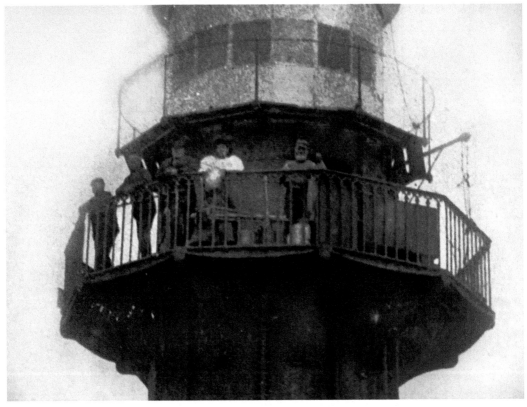

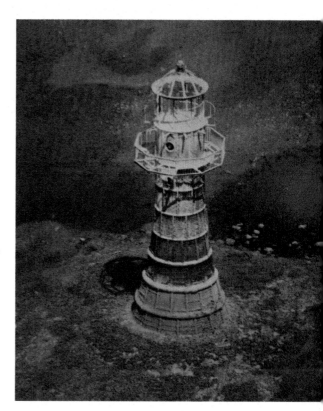

Burry Holms Light
Whitford Point is an unusual cast-iron lighthouse, built in 1865 by the Llanelli Harbour and Burry Navigation Commissioners to a design by John Bowen (1825–73) of Llanelli. A scheduled ancient monument; it is also listed by CADW as Grade II because it is a rare survival of a wave-swept nineteenth-century cast-iron lighthouse in British coastal waters. The lighthouse was taken out of full-time service in 1926, but operated automatically for a limited period in the 1980s. The lower photograph was taken in October 2010 at low tide by Jennifer Trollope.

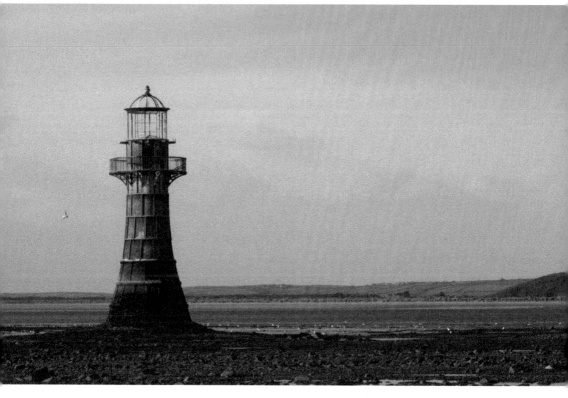

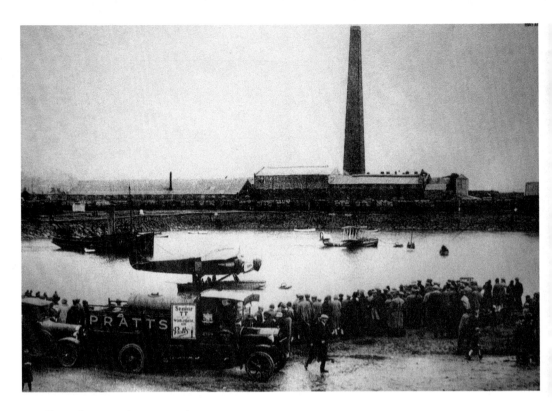

Amelia Earhart Lands at Burry Port

Aviation history was created, and Burry Port put on the map, when Amelia Earhart's Fokker *Friendship* seaplane touched down in the Burry Estuary at 12:40 p.m. on 18 June 1928. Lost after an epic journey of 2,300 miles from Newfoundland, North America, the seaplane landed at Burry Port believing it to be Valentia in Ireland. The other seaplane in the top photograph was a Supermarine Sea Eagle G-EBFR airline flying boat, sent along by Imperial Airways to ensure that Amelia would reach her final destination of Southampton.

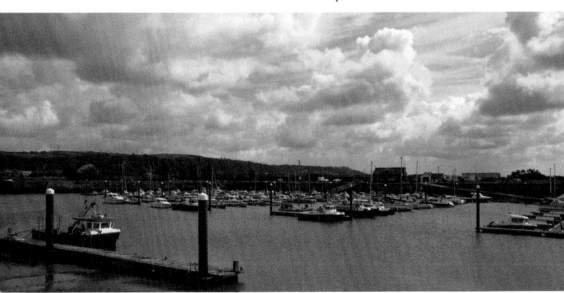

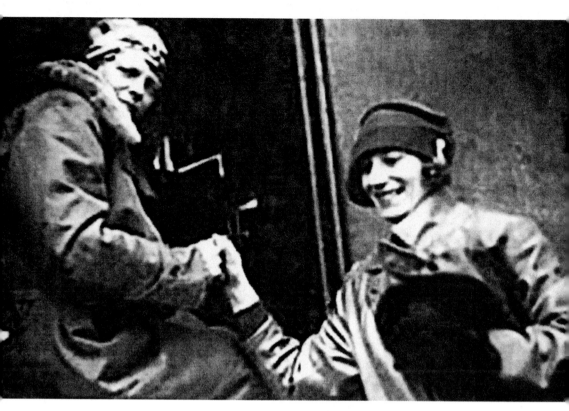

Amelia Earhart – The First Woman to Fly the Atlantic

Not an event to be missed. Crowds were out to welcome Amelia and she was congratulated on her achievement by Mrs Millie Morris, wife of Cllr Brinley Morris, chairman of Burry Port UDC. Accompanied by pilot Wilmer 'Bill' Stultz and navigator/co-pilot/mechanic, Louis 'Slim' Gordon, Amelia's record-breaking flight across the Atlantic as a female passenger, had taken twenty hours and forty minutes. A commemorative flight to Burry Port was made in June 1990 by German pilots Marion Hof and Dr Angelica Machinek. A plaque was unveiled to mark the occasion.

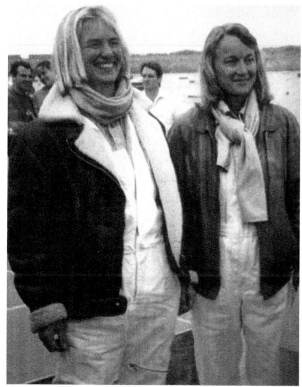

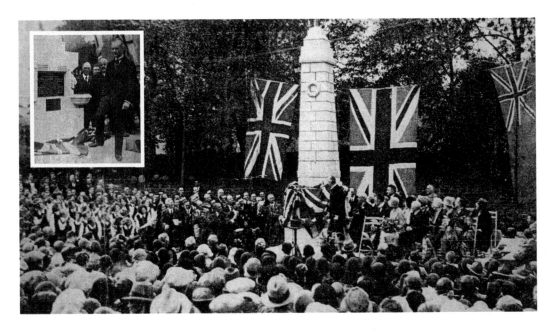

Amelia Earhart Memorials

There are a number of memorials in Burry Port that commemorate Amelia Earhart as the first woman to cross the Atlantic Ocean by air. The main memorial in Stepney Road was unveiled on 8 August 1930, by Sir Arthur Whitten-Brown, KBE, who, with the late Sir John Alcock, KBE, made the first non-stop aerial crossing of the Atlantic. Three other memorials exist on the dockside at Burry Port; the original buoy to which the Fokker *Friendship* was moored, an upright carved memorial stone, and a set of carved paving slabs.

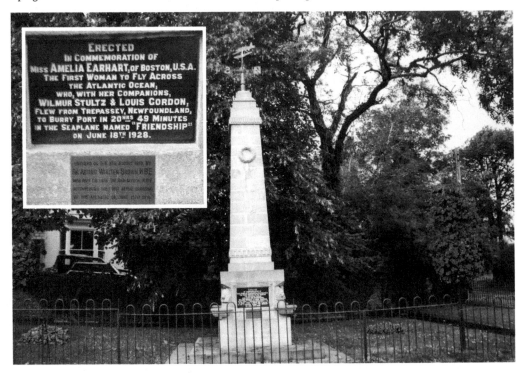

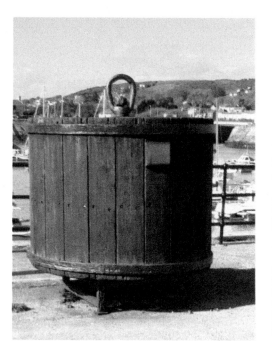
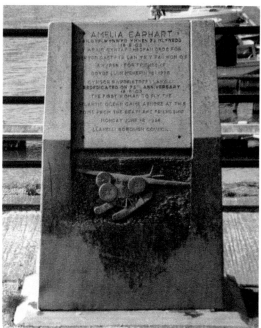

Amelia Earhart Memorials

The following epitaph to Amelia Earhart is carved in paving stones on the dockside:

IN COMMEMORATION OF AMELIA EARHART 1897–1937

The first woman to fly across the Atlantic with companions
Wilmer Stulz and Louis Gordon, flew from Trepassey Newfoundland to
Burry Port in 20 hours 40 minutes in the seaplane "Friendship" 18th. June 1928.

Memories of Amelia Earhart's landing are anchored in the history of Burry Port. Amelia, a pioneer
in her time, became one of the most famous women pilots.
She was lost in the Pacific in 1937

'ADVENTURE IS WORTHWHILE IN ITSELF'

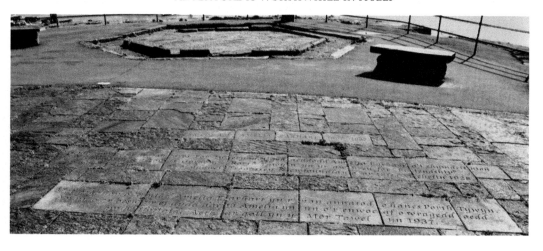

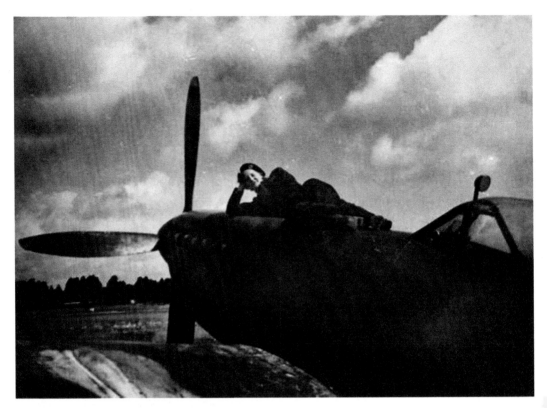

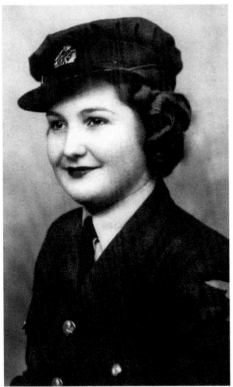

RAF Pembrey at War

Marjorie Amelia Edmunds (née Thorne) was born in Burry Port and lived in Llanelli. During the Second World War, she was an engine mechanic in the Women's Auxiliary Air Force (WAAF) servicing Supermarine Spitfires, Hawker Hurricanes and Avro Lancaster Bombers. Marjorie was stationed in England, Ireland and at RAF Pembrey. While in Pembrey, she narrowly escaped an attack when the canteen was bombed just after she had left, killing many of her friends. Marjorie also had the distinction, while she was a child, of seeing Amelia Earhart in Burry Port harbour after her famous flight across the Atlantic in 1928.

RAF Pembrey at War
WAAF Marjorie Amelia Edmunds with other
ground service crew members at RAF Pembrey.
As so much emphasis is placed on the role of the
RAF stations on the east coast of England during
the Battle of Britain, we tend to overlook how
important the RAF stations in South and West
Wales were to the defence of the country during
the Second World War.

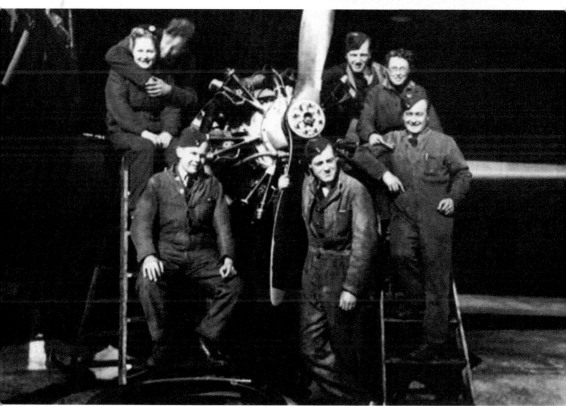

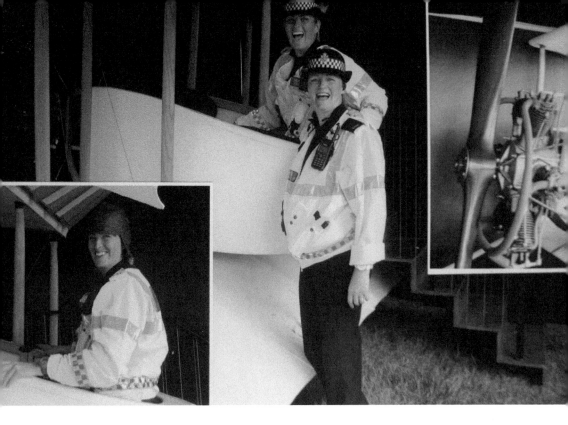

The Flying Squad
Two would-be aeronauts – police constables Eleanor Evans (in the cockpit) and Ruth Courtney – try their hand 'flying' a First World War Radial Engine Bi-plane Flight Simulator at the Science Pavilion, at the National Eisteddfod, Llanelli, 2014.

Acknowledgements

Compilation of this book would not have been possible without all the help and support that I have received from the following organisations and individuals, and for which I offer my sincere thanks and gratitude.

Joe Gallacher, Phil G. Davies and Ann Daniel at Tata Steel Trostre Works Cottage Industrial Museum; Mark Davies, Don Daniels, Nia Lloyd and Hannah Elcock at Parc y Scarlets; Claire Deacon, Joanna Jones and Lydia Giorgi-Allfree at Plas Llanelly House; Lyn John at Llanelli Community Heritage; Mel Edwards, Teresa Bryant and Mandy Jones at Llanelli Town Council; Susan M. Moore at Carmarthenshire County Council; Gavin Evans and Ann Dorset at Parc Howard; Mark Jewel and team at Llanelli Library; Susan Edwards and the Mervyn Rees Photograph Collection; Robert Williams and Rhys Andrews at Sosban Restaurant; Wyn Jones at Lluniau Llwynfan; Peter Owen Jones, photographer; Phil G. Davies, photographer; Arthur Mallett, photographer; Revd Canon Sain Jones, St Elli Llanelli parish church; Cllr Roger Price, Mayor of Llanelli (2014/15); Peter Walker, sculptor; John Edwards, author and local historian, Llanelli; Jennifer Trollope, Swansea; Les George, Burry Port and Jessica Phillips, Pembrey.

Please accept my apologies if I have inadvertently missed out anyone from the above list.